SURREALIST & DADAIST POETRY: AN ANTHOLOGY

BLACK EGG

COMPILED BY JEAN BONNIN

1

Also by Jean Bonnin:

Novels - A Certain Experience of the Impossible; The Cubist's House

Poetry/Aphorisms - Being and Somethingness; Beautiful Wilderness; Dreams Within Dreams; The Bearable Lightness of Being

Translations - Magical Sense (by Malcolm de Chazal); Magical Science (by Malcolm de Chazal)

Edited by Jean Bonnin - The Nuremberg Trials: A Personal History (by Georges Bonnin)

and

Surrealism in Wales;
Surrealism in Wales: Artworks and Images

Jean Bonnin

...is half French half Welsh. He was born in Lavaur, in the Tarn in France, in the year of the deep snows... He took his first degree in government and politics in Birmingham, and his Masters in political philosophy at Hull; his doctoral research was on the theories of despotism. These days, he is a novelist, poet, graphic designer, artist, and translator of surrealist texts. Specifically, he is the translator of Malcolm de Chazal's Magical Sense (*Sense Magique*). He is also the inventor of surrealist ping pong... Through a combination of hard work and serendipity Jean Bonnin has achieved anonymity in New York, Paris, Berlin, London and Wales.

He is a great believer in the following quote by William Burrough's: "The dream is a spontaneous happening and therefore dangerous to a control system set up by the non-dreamers."

Surrealist and Dadaist Poetry: An Anthology

An Original Publication of Black Egg Publishing
An imprint of Red Egg International
First published in the UK by Red Egg Publishing in 2022
www.redeggpublishing.com

British Library Cataloguing-in-Publication Data

A catalogue record for this book is available upon
request from the British Library
ISBN: 978-1-9998215-7-9

While every effort has been made to contact copyright-holders,
if an acknowledgement has been overlooked, please contact the publisher

SURREALIST & DADAIST POETRY:
AN ANTHOLOGY

COMPILED BY JEAN BONNIN

Contents

Anti-INTRODUCTION

Dada is anti-Dada and Surrealism is pro Surrealism and I am a tube of ketchup in a caldron made of snow.

So begins... nothing – absolutely nothing – in the now celebrated and some would say ground-breaking book about nothing, that does not exist.

So begins... this book – here, now, *this* here... what you are reading NOW. Thank you – THE END

Le FIN

--

Welcome to this collection of all that is Dada and Surrealist (and some poems by poets who are related to either movement in one way or another, but who might not necessarily consider themselves to be fully surrealist or dada for whatever reason; or those who were related to the movements for only a short time).

First things first, second things second, and prawn cocktails were quite a popular starter in the UK in the 1980s.

So, firstly then, we should give a brief account of the difference between Surrealism and Dada...

For those keen to comprehend the history, definition, and divergences of the two movements,

whatever you do do not pay any attention to the two diagrams that follow.

d**AD**a as Diagram

Surrealism as Diagram

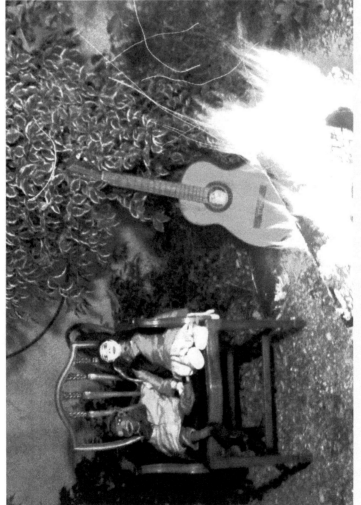

Fire Puppets by Jean Bonnin

INTRODUCTION

In this introduction we will attempt to provide the reader with the following: a brief history and outline of Dada and Surrealism; offer modest biographies of all of the contributors we have decided to include – with a brief description of why we have included each poet in this volume; and finally we will present the reader with an overview as to why we consider Surrealist and Dada poetry to be so significant and indicate what can be expected as we make our way on through the body of this many-tentacled being.

Dada and Surrealism

Here is not the place to offer a lengthy discourse on the differences and similarities, the convergences and divergences, of Surrealism and Dada. There are many good books already in existence that dedicate themselves to just that singular purpose. Notwithstanding, on the premise that those who read these words will consist of both those who are knowledgeable about the subject, as well as the newly intrigued, we will endeavour therefore to sketch out some of the fundamentals.

Most movements, art movements, have a recognisable style – though using the term 'art' is problematic (not least because neither Surrealism nor Dada are art movements). Putting that to one side for the moment there is something that easily, quite easily, allows the observer to describe

such and such as being a work of Pop Art, say, or of Impressionism, or of, for instance, Abstract Expressionism. This is not the case either with Dada or with Surrealism. It is not possible to say that this or that 'artwork', this or that ripple in the surface of reality, or this or that piece of writing is or is not, say, Surrealist... Revolution comes in many forms – and the mere repetition of a style or an approach, or the delivering of expectations, is anti-revolutionary. Indeed, it means that the creator of whatever it happens to be has become yet another cliché-cog absorbed by the machine.

Whereas Dada was an assault and an attack on bourgeois society in all its manifestations – the most abhorrent example of all being how society's grotesque head reared up out of the putrid depths and spewed out the horrors of the first world war – Surrealism wished to forge a new future.

Dada wanted to expose the banality and pointless destructiveness of Western society; shove a mirror right into its face before smashing it to a million shards, with which it hoped that the rich and well-to-do in all milieux of the pointless aberration laughingly called civil society would utilise to self-harm.

Not only, however, was Dada an attack on the social order, and indeed art, it was also an attack on itself. 'Dada is anti-dada', was its cry. Consequently, the nature of Dada is sometimes, oftentimes, seen through the prism of it being 'against-against-against', and it is from this perspective is it usually criticised. The criticism being, 'don't just be against' also be 'in favour of... forge onwards... strive to create something better'.

The merit in this line of attack against dada is for others to consider; however, two things, we suggest, that should not be disregarded are the following: that Dada was

frequently very humorous (not always necessarily intentionally so) – the moustache drawn onto the image of the Mona Lisa, as well as the iron with the nails attached to its ironing surface, for example – by Marcel Duchamp and Man Ray respectively. Nor should it be forgotten that Dada was a precursor to Surrealism, with a large number of those who had considered themselves Dadaists migrating over to Surrealism, along with, at least in its earliest incarnation, a large degree of their same techniques and approaches.

Surrealism, contrariwise… contrariwise to attacking the banal and destructive forces within the greed ridden art world and society, wished and wishes to create a new world, a better world, based upon humanitarian, ecological and revolutionary ideals. Of course, it *condemns* as well, from its revolutionary perspective – but fundamentally it is looking for a way to create a path forward where all opposites and contradictions will be unified. Unified so as to create a new reality … a 'sur'-reality.

Dada died out in those early days (more or less), being superseded, as it was, by Surrealism. However, the movement called Fluxus was to replace many of the approaches and attitudes that Dada had as integral components of its DNA. Fluxus – who some would possibly define as neo-Dada – was a movement that developed in the 1960s and 1970s, which for some was the most radical and experimental movement of that period.

Surrealism conversely continued and if anything became stronger over the years, its internationalist and anti-capitalist stance bedding down to be intertwined with radical causes that were more easily able to be established in the new era of rapid global communications.

The future is bright, the future is optimistic (because it has to be); the future will be more connected to nature and how our primordial ancestors inter-existed with their

surroundings and the pulses of the seasons... The future... the future... the future will be surrealist.

Most, but admittedly not all, of those whose poems we have included here are Surrealists and Dadaists. Some however are precursors, influencers, and those who, for one reason or another, were closely linked to either of the movements.

Stream of Poets

André Breton (1896 – 1966) was born in Tinchebray in Normandy, France. He was a writer and a poet, and the chief theorist of Surrealism. Significantly, he published his (first) Surrealist Manifesto in 1924. **Antonin Artaud** (1896 – 1948) was a poet, dramatist, visual artist, essayist, actor and theatre director who was born in Marseille, France; though had Greek ancestry. **Arthur Rimbaud** (1854 – 1891) was born in Charleville in north-eastern France. Prefiguring surrealism Rimbaud, writer and poet, began writing very early but had completely abandoned his literature by the age of twenty. **Salvador Dalí** (1904 – 1989) is the artist who surrealists love to hate. Not without justification, it must be said. Early member and friend of the original surrealists Dalí fell out of favour with them; culminating in a 'trial' that was held in 1934 at which he was thrown out. Was it a burning kangaroo court? Whatever it was it was true that Dalí was becoming a bit of a whore to money, and even more unforgivably he was – at the very least – ambiguous when

it came to Fascism and Franco. **Philippe Soupault** (1897 – 1990) who was born in Île-de-France, France, was a novelist and poet. Previously active in Dada he was instrumental in aiding André Breton to create Surrealism. **John Welson** (1953 –) was born in Llanfair-Llythynwg, in Wales. Painter, poet, and writer – he is one of the most, if not the most, important living Welsh and Wales-based Surrealists. He co-curated the largest Surrealist exhibition in Wales since the 1980s. It was called 'Surrealist Murmuration' and was held in Aberystwyth in 2017. Third wave surrealist he has exhibited with all the most important and influential surrealists... and has works in many of the major galleries around the world, such as, for example, the Museum of Modern Art in New York, and Tate Britain. **Jean Bonnin** (1967 –) is a poet, writer, musician, and inventor of Surrealist Ping Pong, who was born in the south of France. He is an active member of the Surrealists in Wales. He is the translator of one of Malcolm de Chazal's complete works into English. He also wrote the two books on Surrealism in Wales (by Black Egg Publishing). **Malcolm de Chazal** (1902 – 1981) initially a poet and a writer then subsequently an artist, was born on the island of Mauritius, of French ancestry. Many of the first wave of Surrealists found his writing to be so inspirationally surrealistic and alchemical that several of them, such as Max Ernst and André Breton, independently of each other, wrote to de Chazal to suggest to him to try his hand at painting... The first time he was exhibited in the UK since the late sixties was at the Aberystwyth Surrealist Murmuration exhibition. **Paul Éluard** (1895 – 1952) was born in Saint-Denis in France. A poet, initially a Dadaist then one of the founding members of Surrealism. He paved the way for artistic action to be directly related to being politically committed. His funeral was held in the Père Lachaise Cemetery in Paris, France –

organised by the French Communist Party. **Robert Desnos** (1900 – 1945) surrealist poet who was a member of the French Resistance during the war. He died in a concentration camp in Czechoslovakia. In 1974 a book of his poems illustrated by Joan Miró was published. **Aimé Césaire** (1913 – 2008) born in Basse-Pointe, on the island of Martinique he was a politician as much as he was a surrealist poet. He was one of the founders of the movement Négritude, which was based on radical Marxist philosophy. In 1941 he met André Breton, who became his friend and supporter; and when Césaire's book-length poem *Cahier D'un Retour au Pays Natal* was published in 1947 Breton stated that it "is nothing less than the greatest lyrical monument of our times." **Federico García Lorca** (1898 – 1936) was a Spanish poet, playwright, and theatre director, who was born close to Grenada in a town called Fuente Vaqueros. As a member of the group of Spanish poets called *Generation of '27*, he was enthusiastic to introduce avant-garde, symbolistic, and surrealistic ideas into Spanish literature... He was murdered by the Nationalists (a grouping of right-wingers who would eventually become led by Franco). His body was never found. **Alejandra Pizarnik** (1936 – 1972) was born in Buenos Aires. She was a poet who was greatly influenced by Rimbaud and Mellarmé, and for four years between 1960 and 1964 she resided in Paris. It was during this period that she translated, among others, Antonin Artaud and Aimé Césaire... It has been argued that her poetry resembles the stripped passive melancholia of Hans Bellmer's photographs and sculptures. **Stéphane Mallarmé** (1842 – 1898) was a symbolist poet, born in Paris, who had a strong influence on Dada and Surrealism... Man Ray's final film was heavily influenced by Mallarmé. Called: *The Mystery of the Chateau of Dice*, includes the line – which is

the title of a Mallarmé poem – "A roll of the dice will never abolish chance". **Darren Thomas** (1965 –) film-maker, artist, poet and writer. He was born in Caldicot, Monmouthshire, Wales – is one of the many active Welsh and Wales-based Surrealists, and is one of the founding members of the London Surrealist Group. **Toni del Renzio** (1915 – 2007) poet and graphic designer was born near to what is now called Pushkino, outside St Petersburg; he was of Russian Italian extraction. He spent some time in Spain as part of the Trotskyite faction fighting Franco. In 1938 in Paris, he met Pablo Picasso and André Masson and associated with Benjamin Péret. He had a fleeting affair with Emmy Bridgwater. He was married to Ithell Colquhoun for barely five years, from 1943. In 1942 he mounted a London exhibition entitled *Surrealism*. However E. L. T. Mesens and Conroy Maddox over the same period ostracised him from the movement, with a final definitive split in 1946. **Georges Bataille** (1897–1962) was born in Billom in the region of Auvergne, France. Initially attracted to Surrealism, Bataille quickly fell out with its founder André Breton, although Bataille and the Surrealists resumed cautiously cordial relations after World War II. Bataille was a member of the extremely influential College of Sociology which included several other renegade surrealists. He was heavily influenced by Hegel, Freud, Marx, Marcel Mauss, the Marquis de Sade, Alexandre Kojève, and Friedrich Nietzsche; the last of whom he defended in a notable essay against appropriation by the Nazis... Among other things he was a philosopher, poet and novelist. **Hans Arp** [aka Jean Arp] (1886 – 1966) was born in Strasbourg, France. He was a sculptor, painter, and poet. In 1916 Hugo Ball opened the Cabaret Voltaire, which was to become the centre of Dada activities in Zurich for a group that included Arp, Marcel Janco, Tristan Tzara, and others.

In 1920, as Hans Arp, along with Max Ernst and the social activist Alfred Grünwald, he set up the Cologne Dada group. In 1925 his work also appeared in the first exhibition of the Surrealist group at the Galérie Pierre in Paris. In 1931 he broke with the Surrealist movement to found *Abstraction-Création*. **Hugo Ball** (1886 – 1927) was an author and poet; most fundamental of all was that he was the founder of the Dada movement in 1916 (though some suggest that it can be traced back one, two or three years earlier). He was born in Pirmasens in Germany. In the same year Ball created the Dada Manifesto, making a political statement about his views on the terrible state of society and acknowledging his dislike for philosophies of the past that claimed to possess the ultimate truth... Ball's poem *Gadji Beri Bimba* was adapted for the song "I Zimbra" on Talking Heads' 1979 album 'Fear of Music'. Ball received a writing credit for the song on the track listing. **Tristan Tzara** (1896 – 1963) was born in Moineşti, Bacău County, in West Moldavia. A Romanian and French avant-garde poet, essayist and performance artist, as well as a journalist, playwright, and literary and art critic; he is best known for being one of the founders of Dada. However, he was much more nihilistic than Hugo Ball... In 1917 he moved to Paris. He was a humanist, anti-fascist and later a communist – who managed to make the link between the Beat Generation, Situationism and various currents in rock music. **John Richardson** (1958 –) is a poet, writer and collagist. Now residing in Wales he along with John Welson is responsible for the resurgence of Welsh Surrealist activism. To the extent that Cymru probably has not been this surrealist, one could quite feasibly say, since during Merlin's time. Again, along with Welson he co-curated the largest Surrealist exhibition to be held in Wales for over thirty years: Surrealist Murmuration (as mentioned previously)...

Frequent publisher and contributor to surrealist and radical left-wing journals, books and pamphlets; he is the publisher of the anti-periodical surrealist periodical: *Once Upon A Tomorrow/Un Tro Yfory*. **Guy Girard** (1959 –) was born on New Year's Day in Flamanville, Normandy, France. After discovering Surrealism in 1977 Girard began to write his own poetry and to paint. He moved to Pars in 1984 and joined the Paris Surrealist Group in 1990. **Edith Rimmington** (1902 – 1986) she was born in Leicester in the UK. She was an artist, poet and photographer who was associated with the Surrealist movement. Though the London Surrealists and the Birmingham Surrealists were lesser known than their Parisian counterparts, they nonetheless were often ground-breaking and completely imaginatively original in their surrealistic contributions. She met Dalí at the 1936 *International Exhibition of Surrealism* held from 11th June to the 4th July at the New Burlington Galleries, and continued to be influenced by him throughout most of her career; they, for instance, both shared an interest in themes of death, decay, and re-birth. **Desmond Morris** (1928 –) though born in Purton in Wiltshire in the UK, with a large proportion of his ancestors having come from Wales, Morris is proudly half Welsh. And as such is one of the most significant living Welsh Surrealist artists. **JoëL Gayraud** (1953 –) is a poet, essayist and translator who was born in Paris. He has been active in the Paris surrealist group since 1995. **Benjamin Peret** (1899 – 1959) born in Rezé, France, was a poet, Parisian Dadaist and a founder and central member of the French Surrealist movement. In Autumn 1924 he became the co-editor of the journal *La Révolution Surréaliste*, before becoming its chief editor in 1925. **Pablo Picasso** (1881 – 1973) was a Spanish painter, sculptor, printmaker, ceramicist and theatre designer. He was born in Málaga, Andalusia, in southern

Spain, though spent most of his life in France. Picasso was influenced by, and had some influence upon, surrealism. He had a period of writing surrealist poetry and was friends with or an acquaintance of some of the surrealists. Most well-known however for inventing Cubism and being one of the most innovative and influential artists of the twentieth century. **Alfred Jarry** (1873 – 1907) was born in Laval, Mayenne, in France. His play *Ubu Roi* is often cited as a forerunner to Dada and Surrealism; he is also most well-known for being the person who first coined the term *pataphysics* ('the science of imaginary solutions'). His play *Ubu Roi* was deemed to be so controversial that its rehearsal and first night were the only two times the play was fully enacted during Jarry's lifetime. **Mark E. Smith** (1957 – 2018) was the lead singer and lyricist and dial-turner of the post-Punk group The Fall. From Broughton, Salford, in the UK, he formed the band after going to see the now infamous Sex Pistols gig at the Lesser Free Trade Hall in Manchester in 1976. The Fall had sixty or more members during their existence and released thirty-two studio albums. When asked about the continual revolving doors of his group's line-up he stated: "If it's me and yer granny on bongos, it's the Fall." On his death one journalist summed him up thus: he was a "strange kind of antimatter national treasure"... In a survey carried out for the book 'Surrealism in Wales' by Black Egg Publishing, when the five most active Wales-based surrealists were asked to list their top five surrealist poets of all time, two of them cited Mark E. Smith as being in their lists. **Pierre Unik** (1909 – 1945) was a French poet, journalist, and script-writer. He was born in Paris, considered himself to be a surrealist for some of his time; he joined the Communist Party in 1927; and worked with Buñuel on three films, including the 1933 film *Terre Sans Pain*. **Yvan Goll** (1891 – 1950) was a French-

German poet, who wrote in both languages, from Saint-Dié-des-Vosges, France [through was part of the German Empire at the time of his birth]. Poet and Playwright, his collection *The New Orpheus* was partly illustrated by the Dadaist Georg Grosz, among others. He was good friends with Hans Arp, Tristan Tzara and Francis Picabia... Leading up to 1924 there were two rival surrealist camps, both stating that they were the natural successors to the revolution inaugurated by Guillaume Apollinaire. Hence in 1924 two Surrealist Manifestos were published, one by André Breton and one by Yvan Goll. Goll's Manifesto was published two weeks prior to Breton's; despite this and despite the antagonism they felt for each other – to the extent that they ended up fighting on one occasion over who had the rights to the term 'surrealism' – Breton ended up winning. And it is now his Manifesto that in many ways is seen as the definitive manner by which to define surrealism. Though, and this is crucially fundamental, surrealism is an ever-changing and ever-evolving internationalist movement. **Robert Desnos** (1900 – 1945) in 1922 he published his first book of poetry, which was titled *Rrose Sélavy*, which was the name of the feminine alter-ego of Marcel Duchamp. In 1919 he met Benjamin Péret, who introduced him to the Paris Dada group, and consequently he met André Breton with whom he struck up a fond friendship. After which he became active in the Paris surrealist group. And despite being heavily praised in Breton's 1924 Manifesto as being the 'prophet' of the movement, they were later to irreparably fall out over surrealism's involvement with communism. In 1932 he began a career in radio and subsequently became friendly with the likes of Picasso, Hemingway, and Artaud. **Frida Kahlo** (1907 – 1954) was born in Coyoacán in Mexico City. Her work has been held in high esteem by those who take

her work to be a representation of the female form, identity and experience, as well as being a depiction and representation of the defence of the rights and practices of the oppressed and indigenous peoples of Mexico... In 1938 André Breton went to Mexico to visit Leon Trotsky, who lived only a few streets away from Frida Kahlo. When Breton and his wife meet Kahlo and her husband Diego Rivera, and he sees her unfinished painting "What the Water Gave Me", he instantly calls her an innate 'surrealist'. And subsequently helps to organise some exhibitions for her. **Dorothea Tanning** (1910 – 2012) born in Galesburg, Illinois, USA. She was a painter, printmaker, sculptor, writer, and poet whose early work, especially, but not exclusively, was heavily influenced by Surrealism. She was married to Max Ernst between 1946 until his death in 1976. **Kay Sage** (1898 – 1963) born in Albany, New York, USA. Artist and poet who self-identified as a surrealist; one of her biographers, Judith Suther, said the following about Sage: "I call Kay Sage a Surrealist because her painting resonates with the unsettling paradoxes and hallucinatory qualities prized by André Breton and his group... More fundamentally, I call Sage a Surrealist because her allegiance to the Surrealist identity lies at the heart of her self-image as an artist." **Aaron Kent** (1989 –) defines himself as a working-class writer and publisher from Cornwall, though now is residing in Wales. His work is completely original and in a way signals a departure, if a fundamentally fascinating one, for surrealism. **Ivor Unsk** (? – 1916) Russian immigrant, poet and drinking buddy of Marcel Duchamp, asked one day in 1915 "What is the difference between a ketchup label, and a poem?"... The *Papa Says It Won't Hurt Us* 'poem' that we include in this book was written by Unsk in 1915, two years before Marcel Duchamp conceived of his 'Fountain'. Although it could

easily be argued that Unsk invented the *Readymade*, he was mercilessly made fun of at the time. Published in the newspaper in 1915, one of the resident critics said the following: "Unsk's poem is the worst choice of plagiarism of the last hundred years, and his argument about ketchup labels constituting literature is the equivalent of saying that the substance of ketchup is superior to fine French cuisine. If you take a real poem out of a book and publish it in a newspaper, or scrawl it on a bathroom wall, it is still a poem. But merely typing your name under an advertisement does not make an instantly forgettable slice of promotional prose into poetry, unless the reader has had as much Vodka as has Unsk."... And what happened next is a sort of tragi-poetry in itself. In 1916 Ivor Unsk was killed attempting a robbery to pay-off his drinking and gambling debts... His poem about Iver Johnson revolvers is the only example of his poems that has survived... And how was he killed while trying to carry out his burglary? He was shot by an Iver Johnson revolver. **Méret Oppenheim** (1913 – 1985) was a Surrealist artist and photographer born in Berlin. She was one of very few female artists to be internationally recognised while she was still alive. Her most well-known piece is *Object*, which consists of a teacup, saucer and spoon covered with fur. Oppenheim was Swiss, despite having been born in Berlin, and in May 1932, at the age of 18, she moved to Paris from Basel, Switzerland. She soon became acquainted with Alberto Giacommetti, Hans Arp, Marcel Duchamp and Man Ray. And was very soon displaying alongside the likes of Salvador Dalí and Giacommetti. **Gérard de Nerval** (1808 – 1855) writer and poet born in Paris, his last novella, *Aurélia*, was an influence upon André Breton and Surrealism. Apart from, according to Marcel Proust, being one of the greatest writers of the nineteenth century, de Nerval was also well-known for

taking a pet lobster for walks around Paris on a lead… Virtually penniless and distressed, in 1855 he committed suicide in the *rue de la Vieille-Lanterne*; one of the seediest alleyways in Paris. The note he left to his Aunt read, "Do not wait up for me this evening, for the night will be black and white." Charles Baudelaire stated that de Nerval had decided to deliver "his soul in the darkest street that he could find." He was buried in the Père Lachaise Cemetery in Paris, paid for by his friends. **Guillaume Apollinaire** (1880 – 1918) the poet, playwright, short story writer and novelist was born in Rome, Italy. An important forerunner to surrealism he wrote one of the earliest Surrealist literary works, the play *The Breasts of Tiresias* (1917). Indeed it was Apollinaire who first coined the term in relation to the 1917 ballet *Parade*. And the term appeared for the first time in *Chronologie de Dada et du surréalisme* from March 1917, in which appears a letter from Apollinaire to Paul Dermée where he states: "All things considered, I think in fact it is better to adopt surrealism than supernaturalism, which I first used." **Max Jacob** (1876 – 1944) was born in Quimper, Finistère, Brittany, in France. Jacob is frequently seen as an important link between the Symbolists and the Surrealists. Meeting in 1901 he became one of the first friends Picasso made on moving to Paris. Jacques Lacan the psychoanalyst attributes the quote "The truth is always new", to Jacob. **Pierre Reverdy** (1889 – 1960) born in Narbonne, France, although often closely associated with Dada and Surrealism he liked to remain independent. While in Paris he met Guillaume Apollinaire, Max Jacob, Louis Aragon, André Breton, Philippe Soupault and Tristan Tzara. Nevertheless he always remained slightly apart, searching for, within his writing and his psyche, "the sublime simplicity of reality." **Paul Dermée** (1886 – 1951) born in Liège, Belgium. He was a writer and poet, and he along with his wife Céline

Arnauld, were active in the Paris Dada movement. For diffusing the Dada review during wartime he was given the title of 'Proconsul Dada'. He was also director of the magazine *L'Esprit Nouveau*; a magazine founded by architect Le Corbusier, poet Paul Dermée, and painter Amédée Ozenfant in 1920. **Céline Arnauld** (1885 – 1952) was born in Calarashi, Romania. Her poems appeared in numerous Dada and Proto-Surrealist periodicals. In May 1920 the *Vingt-trois Manifestes du Mouvement Dada* was published, and her Manifesto: *Ombrelle Dada* was the only one by a woman to be published as part of the Manifesto. **Pierre Albert-Birot** (1876 – 1967) born in Angoulême, France, he was a poet and dramatist. His journal *SIC*, was often a focal point during those dark war years, published as it was between 1916 and 1919. Frequent contributors were Apollinaire, Reverdy, Tzara, and Aragon for example. His visual poetry has been somewhat forgotten over time, possibly because of his mistrust of 'isms' as much as anything else. **Louis Aragon** (1897 – 1982) was a poet who was born in Paris. Along with André Breton and Philippe Soupault he was one of the most important architects of Surrealism, and with them was co-founder of the surrealist review *Littérature*. After 1959 he was a frequent nominee for the Nobel Prize for literature... The singer and poet Léo Ferré dedicated an entire album to Aragon, with his 1961 breakthrough LP *Les Chansons d'Aragon*. **Arthur Cravan** (1887 – 1918) born in Lausanne, Switzerland, was a writer, poet, artist and boxer... Cravan's rough vibrant poetry and anarchic lectures, coupled with his often over-the-top public appearances – which frequently resulted in inebriated brawls – earned him the admiration of Marcel Duchamp, Francis Picabia, and André Breton among others. He travelled extensively during World War I, usually on false passports, stating that he had no single nationality and

instead was the citizen of twenty nations; finishing up in New York between 1916 and 1917, arriving on the same ship as Leon Trotsky. Though he never self-proclaimed as a Dadaist the New York Dada scene happily adopted him as one of their own. **Elsa Von Freytag-Loringhoven** (1874 – 1927) born in Swinemünde, was a German avant-garde, Dadaist artist, poet and sound-poet. She was an early female pioneer of sound poetry and was called by some 'the first American Dada'… Intriguingly in a letter from Marcel Duchamp to his sister in 1917 he states the following in reference to his pissoir readymade, that he called 'Fountain': "One of my female friends under a masculine pseudonym, Richard Mutt, sent in a porcelain urinal as a sculpture." The speculation as to who this female friend could have been – since Duchamp never names her – has put Elsa Von Freytag-Loringhoven in the frame, as well as a friend of his Louise Norton, and indeed his own female alter ego Rrose Sélavy. **Julien Torma** (1902 – 1933) was a French writer, playwright and poet. Born in northern France and then went missing in the Tirol thirty-one years later; his body never to be found. He was Dada, though really he was beyond Dada, more closely akin to Alfred Jarry's Pataphysics maybe than to Parisian Dada. He somewhat admirably rejected all forms of commitment, whether that be moral, religious, social or political. And the fact that he was published at all during his lifetime, or after, was almost completely due to happenstances rather than anything to do with his want, need, or desire to forge out a literary career, or indeed any concern for posthumous recognition or longevity of reputation. **Jacques Rigaut** (1898 – 1929) was a poet. He was born in Paris and was attracted by the Parisian Dada movement. Dandy and drug-addict, the 'unity of opposites' so sought-after and fuelled-towards by those of these movements, were embodied

within him. Throughout his life he was the tightrope balancing act of the life-death conundrum. The result of which was his announcing (some time before) that he would kill himself; and so he did in 1929. **John Heartfield** (1891 – 1968) was an anti-Nazi and anti-fascist artist who was born in Berlin. In 1917 he became a member of the Berlin Club Dada, and became an increasingly active participant, helping to organise the *First International Dada Fair* in Berlin in 1920. Dadaists would frequently disrupt public art gatherings, mocking the participants for being trivial puppet mouthpieces for the bourgeois constructs out of which society was constructed... In 1918, Heartfield joined the German Communist Party. **Robert Calvert** (1945 – 1988) was born in Pretoria in South Africa but moved to the UK at the age of two. He began writing and performing his poetry in about 1967. He formed a street theatre performance group called 'Street Dada Nihilismus'. Soon thereafter he began initially as a so-to-speak poet-in-residence with the British space-rock group Hawkwind, before progressing on to being their sometime lead singer; and co-writing their hit record *Silver Machine*. He was a lifelong friend of the formidable science fiction writer Michael Moorcock... Inscribed on his gravestone, from William Shakespeare's Sonnet 116, is "Love's not Time's fool". **Emmy Hennings** (1885 – 1948) born in Flensburg, Germany, she was a performer and a poet. She was also the wife of the Dadaist Hugo Ball. William Seaton says of her, "She took risks, agitating for revolution and forging documents for draft dodgers (for which she received a brief prison sentence). She worked for a time as a prostitute and her one surviving child was brought up by her mother. Her work expresses the malaise of the era and the Bohemian reaction, heavy with dread yet scintillating with spirit and extravagance." **Richard Huelsenbeck** (1892 – 1974) was

born in Frankenau, Germany. On the eve of World War I he moved to Zürich in Switzerland where he became active with the Dadaists involved with the Cabaret Voltaire. A year later he moved to Berlin where he helped found the Berlin Dada group. Stating as he did, along with others, that "Dada is German Bolshevism" meant (along with many other reasons) that he would be threatened and investigated by the Nazis in the years to come. Huelsenbeck was the editor of the *Dada Almanach*, and wrote *Dada siegt, En Avant Dada* as well as other Dadaist works... Until his death he continued to insist that "Dada still exists." **Hans Leybold** (1892 – 1914) was a German poet one of whose best friends was the Dadaist Hugo Ball. His absurdist musings had a great influence upon Dada despite his unfortunate death two years before its commencement. **Clément Pansaers** (1885 – 1922) was a Belgian Dadaist poet who was born in Neerwinden. He gave up his career as an Egyptologist to, among other things, publish the review *Résurrection*. He moved to Paris in 1921. **Francis Picabia** (1879 – 1953) was a poet and painter who was born in Paris. He was one of the major characters in early Dada, later being briefly associated with Surrealism... While in Barcelona, in 1916, he published his Dada review *391*. In 1922, André Breton relaunched *Littérature* magazine with cover images by Picabia. **Georges Ribemont-Dessaignes** (1884 – 1974) born in Montpellier in France, he was a painter, playwright, writer and poet. He contributed to the Dada then Surrealist journal *Littérature*. **Hans Richter** (1888 – 1976) was an artist and film-maker who was born in Berlin, Germany. In 1916 he moved to Zurich and joined the Dada movement. Richter believed that the task of any artist was to be a revolutionary and to oppose war. Richter's film *Rhythmus 21* is an important early example of abstract film. **ELT Mesens** (1903 – 1971) was a Belgian artist closely associated with the

Surrealists who was born in Brussels, Belgium. Author of Dada poems. He was a lifelong friend of Magritte and in 1934 was the first to organise a surrealist exhibition in Belgium. Between 1938 and 1940 he became the editor of the London Review which was the most significant of the English language bulletins. According to the poet, artist and historian and co-founder of the Chicago Surrealist Group Franklin Rosemont, Mesens committed "suicide by absinthe". **Raoul Hausmann** (1886 – 1971) born in Vienna, Austria. He was one of the founders and active members of the Berlin Dada scene. He was an artist and poet and sound-poet. His most famous artistic construction is *Mechanical Head (The Spirit of Our Time)*. In the 1950s there was a revived interest in Dada and Hausmann keenly exchanged letters with the younger artists, such as Jasper Johns. Some have said that it was Hausmann who first came up with the term 'Fluxus' since he so hated the label neo-dada. He is as well-known for his sound-poems as much as anything else. **Ernst Jandl** (1925 – 2000) Born in Vienna, Austria. Most well-known for his experimental sound poems, which were heavily influenced by Dada. **Delia Derbyshire** (1937 – 2001) was born in Coventry in the UK. She is most well known for working for the BBC's Radiophonic Workshop, and for being the composer of the science fiction television programme Doctor Who's theme tune. Her cut-up and splicing methods of sound, the results of which transport one to where in the foggy distance one can see the contradictions of the universe beginning to unify, are often Dada-sound-Dada... **Grace W. Pailthorpe** (1883 – 1971) was a British surrealist painter born in St Leonards-on-Sea. She contributed to the *International Surrealist Exhibition* held in London in 1936. **Kurt Schwitters** (1887 – 1948) was a poet and artist who was born in Hannover in Germany and who died in Kendal in the UK. According to Raoul Hausmann, Schwitters joined

the Berlin Dada group in late 1918 or early 1919. One of his earliest Dada contributions was to write a story which was published in *Der Sturm* in 1922 featuring an innocent bystander who began a revolution "merely by being there". An early example of sound poetry, called *Ursonate* was written by Schwitters in 1922, influenced by Raoul Hausmann's own sound poem called *fmsbw*, which he had seen Hausmann recite in Prague in 1921. He remains an important influence on artists even today. **Philippe Soupault** (1897 – 1990) was a French writer, poet, and political activist. He was an enthusiastic member of Dada, and later was influential in the founding of Surrealism. Along with André Breton and Louis Aragon, Soupault began the periodical *Littérature* in Paris in 1919, which, for many, marks the beginnings of Surrealism. **Rowena Morfydd (Lyn) Bonnin** (1923 –) storyteller and co-translator of some of the surrealist Malcolm de Chazal's writings, Bonnin has always lived her life with a strong appreciation of the absurdity of everything, a love of poetry – both written poetry and the poetry of nature – and has always been a political activist. **Jacques Prévert** (1900 – 1977) was a French poet born in Neuilly-sur-Seine. He spent a sizeable proportion of his young adulthood with many from the clan of surrealist artists, such as Robert Desnos, Yves Tanguy, Louis Aragon, and André Breton. The headline of an article about Prévert in The Irish Times dated March 8th 2000, was 'Surrealist poet of the streets commemorated'. His poems are intriguing for many reasons, one being that he reintroduced the 'song poem'. Many of his 'paroles' have been sung by popular artists, such as Joan Baez and Édith Piaf… He was politically active fighting the Nazis. **Conroy Maddox** (1912 – 2005) English surrealist painter, collagist, writer and lecturer; and a key figure in the Birmingham Surrealist movement. He was born in Ledbury in

Herefordshire in the UK. Following the war he moved to Balsall Heath in Birmingham, UK, where he experienced his most productive period. He was inspired by artists such as Max Ernst, Óscar Domínguez and Salvador Dalí, and officially joined the British Surrealist Group in 1938. **Patrick Lepetit** (1953 –) is a French essayist, collagist, artist and poet. He has written many books on surrealism including, for example, *The Esoteric Secrets of Surrealism* ('Inner Traditions'). He has also had numerous poetry books published including, with John Welson, *Earthly Kingdoms and Dreamy Knights*, ('Black Egg Publishing'). **Nick Pope** (1964 –) is an anarchist Punk poet and artist who was born in Staffordshire, in the Midlands, UK; though now resides on the Welsh border. Pope is anti-pope, anti-art and quite Dada... Punk-Dada. **David Gascoyne** (1916 – 2001) he was an English poet born in Harrow who was associated with the British Surrealist Group. He was an active anti-fascist, who, for example, took part in several protests against the British Union of Fascists in London's East End. **Paul Celan** (1920 – 1970) was born in Cernăuți, which was in Romania but is now in Ukraine and called Chernivtsi. He was a poet and translator. His earlier works show strong signs of his surrealistic influences and appreciation. **Ted Joans** (1928 – 2003) was an American jazz poet, surrealist, trumpeter, and painter who was born in Cairo, Illinois, USA. He was a participant in the Beat Generation in Greenwich Village. He was a friend of Jack Kerouac and Allen Ginsberg and once shared a room with Charlie Parker. He often took part in events organised by the Chicago Surrealist Group. **Jean-Pierre Duprey** (1930 – 1959) was born in Rouen in Normandy, France. Where, as it happens, Marcel Duchamp went to school thirty or so years beforehand at the Lycée Pierre-Corneille... Duprey was a poet and sculpture. André Breton was taken by his poetry and invited him to Paris in

1948. He was arrested for urinating on the flame of the Unknown Soldier. In 1959 on finishing, what would be his final book, he asked his wife to seal it and send it to Breton. On her return from the post office she found that her husband had hanged himself. **Allan Graubard** (? –) is a poet, writer and playwright. Influenced by Surrealism he has written, with Rik Lina, *Language of Birds* ('Anon Editions, NY/Flagstaff'); and, for example, a contributing author to *The International Encyclopedia of Surrealism* (Bloomsbury). **René Char** (1907 – 1988) was a poet and member of the French Resistance during the war. Born in L'Isle-sur-la-Sorgue, France, he was a close friend to the writers and artists: Albert Camus, Georges Bataille, Pablo Picasso, Joan Miró and Victor Brauner. **Philip Lamantia** (1927 – 2005) was an American poet who was born in San Francisco. His poetry was frequently visionary, ecstatic, and erotic, that explored the subconscious and the world of dreams. His writing appeared in the last issue of the Surrealist Magazine *VVV* when he was sixteen. He was in the fifteen minute experimental film by Maya Deren called *At Land* (1944). He was involved with the Beat Generation poets and the USA's Surrealist Movement. He was a writer/creator of 'concrete poetry'. In the 1950s he engaged in Peyote hallucinogenic mushroom taking with native peoples from Mexico and the USA... Nancy Peters, his wife, and, among other things, co-owner of the progressive publishing company 'City Light Books', said the following of her husband: "He found in the narcotic night world a kind of modern counterpart to the Gothic castle – a zone of peril to be symbolically or existentially crossed." **Joyce Mansour** (1928 – 1986) was a surrealist poet born in Bowden in the UK, to Egyptian-Jewish parents. From 1954 Mansour became actively involved with the second wave of surrealists. Her apartment in Paris became a regular

gathering point for the Paris surrealists. She collaborated with the likes of Hans Bellmer, Ted Joans, and Pierre Molinier, for instance. **Hugh Sykes Davies** (1909 – 1984) was born in Prescot, Merseyside, UK. He was a poet and novelist who was one of the few British surrealists around in the 1930s. In the same decade he spent some of his time in Paris. He was one of the co-organisers of the London International Surrealist Exhibition, which was held in 1936. **Ithell Colquhoun** (1906 – 1988) was a British painter, poet and author who was born to British parents in Shillong, India. She visited André Breton in Paris in 1939, which was the same year as she joined the British Surrealist Group and the year she exhibited with Roland Penrose. Her first article was called *The Prose of Alchemy*... Her reading of Aleister Crowley and her occultist tendencies eventually got her thrown out of the British Surrealist Group. **Jacques Brunius** (1906 – 1967) was a French actor, director and writer who was born in Paris and died in Exeter UK. He was assistant director to Luis Buñuel on the film *L'Âge d'Or*. He was a member of the surrealist group in Paris, then of the surrealist group in Britain once he had moved to the UK. He was friends with, for example, E.L.T. Mesens, Conroy Maddox, and Ithell Colquhoun... Jeanette Edwards the Welsh actress who appeared in television programmes such as 'Hancock's Half Hour' was Brunius' last love interest. She acted in the last, unfinished, 1965 film by Brunius and Robert Benayoun. **Emmy Bridgewater** (1906 – 1999) was an artist and a poet who was closely connected to the surrealist movement. She was born in Edgbaston in Birmingham. From the moment she attended the London International Surrealist Exhibition in 1936, her work changed... It was there that she met significant members of the Birmingham surrealist group such as Conroy Maddox, and John Melville and Robert Melville... Michel Remy,

author of *Surrealism In Britain* (Routledge), states that Emmy Bridgewater's entrance onto the British surrealist scene is as significant as Dalí's arrival was to the French surrealists. **Charles Henri Ford** (1908 – 2002) was a poet, filmmaker, novelist and photographer. Born in Brookhaven, Mississippi, USA, he became editor of the Surrealist magazine *View* (1940–1947) in New York City. Taking full advantage during those war years of publishing and befriending the sizeable troupe of surrealists who had escaped Europe to locate in the relative safety of New York… making New York City a formidable centre for Surrealism outside of its foundational European bases. **Herbert Read** (1893 – 1968) was born in Muscoates, in the North Riding of Yorkshire, UK. He was a poet, philosopher, and art historian. He was a prominent Anarchist and supporter of Henry Moore and Barbara Hepworth. Read was one of the organisers of the London International Surrealist Exhibition in 1936 and editor of the book *Surrealism*, which was also published in 1936, which included contributions from the likes of André Breton, Hugh Sykes Davies, and Paul Éluard. **Yves Elléouët** (1932 – 1975) was a poet, painter, and writer who was born in Fontenay-sous-Bois in France. Attracted by Surrealism he becomes friends with André Breton and his daughter Aube who he later marries in 1956. After which they set themselves up in the former studio of David Hare and Jacqueline Lamba, in Paris. He participates in the 1959-60 International Exhibition of Surrealism in Paris… **Mário Cesariny de Vasconcelos** (1923 – 2006) was a Portuguese painter and surrealist poet. He met André Breton in 1947, and along with Alexandre O'Neill and José-Augusto França founded the Lisbon Surrealist Movement… He spent time in France and the UK in the sixties and seventies.

"Who's there? ... Ah, splendid, show in the infinite."
Louis Aragon

NOTES ON POETRY

"A poem must be a debacle of the intellect. It cannot be anything but.

Debacle: a panic stampede, but a solemn, coherent one; the image of what one should be, of the state in which efforts no longer count.

In the poet:

the ear laughs;

the mouth swears;

It is intelligence, alertness that kills;

It is sleep that dreams and sees clearly;

It is the image and the hallucination that close their eyes: It is lack and lacuna that are *created*."

André Breton & Paul Éluard *Notes sur la poésie (La Révolution surréaliste, No. 12, Décembre 15, 1929)* [extract]

Poetry is the lifecycle of infinity condensed; it is the bypass of reason; it is dream as it ties its shoelaces onto barefoot dance; rain inside an empty room; the sound of a mirror's reflection; memories of future protests; the invisible pipe of smoking revolution revolved; the beauty of idleness; the point where the points begin to become pointed... it is where we achieve what we did not set out to do, for we set out with nothing towards nothing – there is no end... Journey, beauty, everything always forever; trust in the voyage towards and through the just out-of-focus...

...the dream beat of a passing cloud...

SURREALIST & DADA POETRY:
AN ANTHOLOGY

COMPILED BY JEAN BONNIN

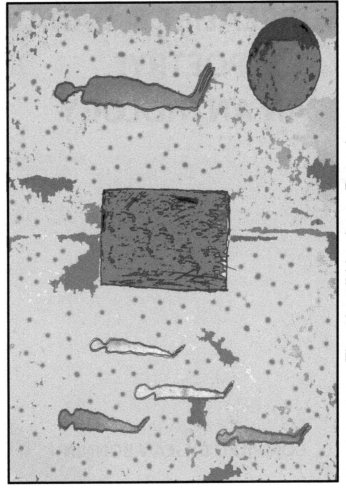

Floating IV by Jean Bonnin

Untitled by Patrick Lepetit

41

Choose Life
by André Breton

Choose life instead of those prisms with no depth even if
their colours are purer
Instead of this hour always hidden instead of these
terrible vehicles of cold flame
Instead of these overripe stones
Choose this heart with its safety catch
Instead of that murmuring pool
And that white fabric singing in the air and the earth at the
same time
Instead of that marriage-blessing joining my forehead to
total vanity's
<div align="center">Choose life</div>

Choose life with its conspiratorial sheets
Its scars from escapes
Choose life choose that rose window on my tomb
The life of being here, nothing but being here
Where one voice says: Are you there
Where another answers: Are you there
I'm hardly here at all alas
And even when we might be making fun of what we kill
<div align="center">Choose life</div>

Choose life choose life venerable Childhood
The ribbon coming out of a fakir
Resembles the playground slide of the world
Though the sun is only a shipwreck
Insofar as a woman's body resembles it
You dream contemplating the whole length of its
trajectory

Or only while closing your eyes on the adorable storm
named your hand
 Choose life

Choose life with its waiting rooms
When you know you'll never be shown in
Choose life instead of those health spas
Where you're served by drudges
Choose life unfavourable and long
When the books close again here on less gentle shelves
And when over there the weather would be better than
better, it would be free yes
 Choose life

Choose life as the pit of scorn
With that head beautiful enough
Like the antidote to that perfection it summons and it
fears
Life the makeup on God's face
Life like a virgin passport
A little town like Pont-á-Mousson
And since everything's already been said
 Choose life instead

Dark Poet
by Antonin Artaud

Black poet, a maiden's breast
You obsess
Bitter poet, bulla life
And the city burns,
And the sky is solved in rain,
And your pen spreads the heart of life.
Jungle, jungle, tingling eyes
In multiplied pinnacles;
Storm hair, the poets
Ride on horses, dogs.
The eyes are enraged, the languages revolve
The sky flows in the face
Like blue milk nourishment;
I am aware of your mouths
Women, hard hearts of vinegar.

A Season in Hell
by Arthur Rimbaud

A while back, if I remember right, my life was one long
party where all hearts were open wide, where all wines
kept flowing.
One night, I sat Beauty down on my lap.
And I found her galling.
And I roughed her up.
I armed myself against justice.
I ran away. O witches, O misery, O hatred, my treasure's
been turned over to you!

Hidden Faces
by Salvador Dalí

Then an unheard-of being, unheard-of beings, will be seen
to rise, their brains compressed by sonorous helmets,
their temples pierced by the whistling of air waves, their
bodies naked, turned yellow by fever, pocked by deep
vegetal stigmata swarming with insects and filled to the
brim with the slimy juices of venom, overflowing and
running down a skin tiger-striped and leopard-spotted by
the gangrene of wounds and the leprosy of camouflage,
their swollen bellies plugged to death by electric umbilical
chords tangling with the ignominiousness of torn
intestines and bits of flesh, roasting in the burning steel
carapaces of the punitive tortures of gutted tanks.

That is man! Backs of lead, sexual organs of fire, fears of
mica, chemical hearts of the televisions of blood, hidden
faces and wings … always wings, the north and south of
our being!

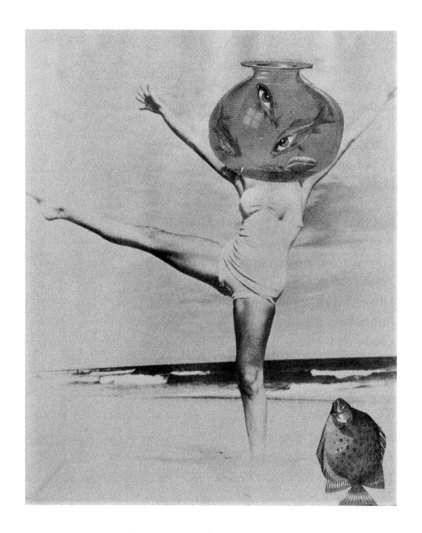

Song of the Siren by Darren Thomas

Towards the night
by Philippe Soupault

It's late
In the shade and in the wind
A scream rises with the night
I do not wait for anyone
to nobody
Not even a memory
The time has passed long ago
But that shout that carries the wind
And push forward
Comes from a place that is beyond
Above sleep
I do not wait for anyone
But here is the night
Crowned by fire
Of the eyes of all the dead
Silent
And everything that had to disappear
Everything lost
We must find it again
Above sleep
Towards the night.

Lazy Broken Glass
by John Welson

Wood-grained car accidents
knee high in stolen misunderstanding,
she smiled
turned around
her lips escaped a kiss.

Now here we have tomorrow
smart suit on,
folded waterfall
dead end spoon in cold desert.
Crippled certainty.

That is right
tongue tied,
lost for words,
you get to your feet,
crumpled paper
of invertebrates.

Around this corner
stone turned butter,
bitter tasting hesitancy,
dog barked flooded infanticide.

Giddy snow tattoos
dance on burnt out flames
as lizard equations lasso the ingratitude of ankles
determined to flee
the welded avalanche of compliance.

The snake oval face.
The crack of an innocent white wall.
The pain of sweat.
The blistered charisma,
oh, we did have fun?

When all is said and done
broken glass sleeps soundly,
conscience clear,
no debts,
no nagging fears,
pliable
the elongated line
the splintered chaos
malleable
this spring of conscience,
it will pass
and
glossed with fallibility
buds, infertile
shiver alone
amidst fingered promises.

At arm's length gossip
sipped and thrown
spat and tapped,
soaked and sodden
free fall,
picked from pavements curbing smudge
it turns and hesitates,
this glance hurts
bruised and blushed,
pulsed and frenzied,
devoid of breath,

it tramples,
the final gasping glance.

The Poet by John Welson

Cool Whispers
by Jean Bonnin

I can hear the cool whispered bells
Ringing out the death knell to our foolish decadence
They will be coming soon
With their horse-whipped hollow laughter
And their golden invites
Singing songs like waves on pebbles
Brushing over our hypnotic currents
Beckoning us on
To the place we wish not to go
Shadows over snow
The place we fear the most
They will be coming soon
With long fingers and long shadows
I feel their damp echoed breath
Taking hold of me
Sweet mystery of silver-lined yesterday
Out of reach
With rounded rock and moonlit bay...
And suddenly it is time
The sullen knock
Propels me trance-like to my coat
Collar up I follow my regrets
It is too late to protest
Someone else must now finish my thoughts
Tidy my desk
And complete my conversations...
I turn, so quickly, as everything has been
For the final breath on my face
And the withering sun

Untitled
by Malcolm de Chazal

The light played leapfrog with the shadows.
Its last leap was into this bouquet of roses
Where it was crushed into shards.

The Only One
by Paul Éluard

The only one
She had in the tranquillity of her body
A small red snowball
Had on the shoulders
A shadow of silence a shadow of rose
Cover by its halo
His hands and docile bows and singers
They broke the light.
She counted the minutes without falling asleep.

I've Dreamed So Much of You
by Robert Desnos

I've dreamed of you so much that you lose your reality.
Is it already too late for me to embrace your living and
breathing body
and to kiss that mouth which is the birthplace of that voice
so dear to me?
I've dreamed of you so much that my arms, grown
accustomed to lying crossed upon my own chest in a
desperate attempt to encircle your shadow, might not be
able to unfold again to embrace the contours of your
body.
And coming face-to-face with the actual incarnation of
what has haunted me and ruled me and dominated my life
for so many days and years
might very well turn me into a shadow.
O, equilibriums of the emotional scales!
I've dreamed of you so much that it might be too late for
me to ever wake up again.
I sleep on my feet, body confronting all the usual
phenomena of life and love, and yet when it comes to you,
the only being on the planet who matters to me now,
I can no more touch your face and lips than I can those of
the next random passer-by.
I've dreamed of you so much, have walked and talked and
slept so much with your phantom presence that perhaps
the only thing left for me to do now
is to become a phantom among phantoms, a shadow a
hundred times more shadowy
than that shadow which moves and will go on moving,
stepping lightly and joyfully across the sundial of your life.

Sun Serpent
by
Aimé Césaire

Sun Snake eye fascinator eye of mine
The sea lice of islands crunching on the fingers of roses
Flaming spear and my intact body fulminated
The water raises the bones of light lost in the corridor
without pomp
Ice whirls aureolan the smoking heart of crows our hearts
Is the voice of the domesticated rays that turn on their
hinges
Of lizard
Transfer of anolis to the landscape of broken glass
Are the vampire flowers that come up to relieve the
orchids
Elixir of the central fire
Fire fair fire mango night covered with bees
My wish a chance of tigers surprised in the sulphur
But the staggering awakening dora with the infantile
deposits
And my pebble body eating fish that eats
Pigeons and dreams
The sugar of the word Brazil in the bottom of the swamp.

Childhood and death
by
Federico García Lorca

To seek my childhood, my God!
I ate rotten oranges, old papers, empty dovecotes
And found my little body eaten by rats
In the bottom of the cistern with the hair of the madmen.
My sailor suit
Was not soaked with the oil of the whales
But I had the vulnerable eternity of the photographs.
Drowned, yes, well drowned, sleep, my son, sleep.
Child defeated at school and in the waltz of the wounded
rose,
Astonished with the dark dawn of hair on his thighs,
Amazed at his own man who chewed tobacco in his
Sinister side
I hear a dry river full of canned
Where they sing the sewers and throw the shirts full of
blood.
A river of rotten cats that pretend corollas and anemones
To deceive the moon and to lean sweetly on them.
Here alone with my drowned.
Here alone with the breeze of cold mosses and tin covers.
Here, alone, I see that the door has been closed.
I have closed the door and there is a group of dead
That plays to the target and another group of dead
Looking for the kitchen melon shells,
And a solitary, blue, unexplained dead
Who is looking for me on the stairs, who puts his hands in
the cistern

While the astros fill the locks of the cathedrals with ash
And the people suddenly stay with all the small costumes.
To seek my childhood, my God!
I ate squeezed lemons, stables, withered newspapers
But my childhood was a rat that fled through a dark
garden
And that he wore a golden gate between his tiny teeth.

Ashes
by
Alejandra Pizarnik

The night was splintered with stars
Looking at me in amazement
The air throws hate
Embellished his face
with music.
Soon we will go
Arcane dream
Ancestor of my smile
The world is emaciated
And there is a lock but no keys
And there is dread but no tears.
What will I do with myself?
Because I owe you what I am
But I do not have tomorrow
Because I love you...
The night suffers.

The Tomb of Edgar Allan Poe
by Stéphane Mallarmé

Such as eternity at last transforms into Himself,
The Poet rouses with two-edged naked sword,
His century terrified at having ignored
Death triumphant in so strange a voice!

They, like a spasm of the Hydra, hearing the angel
Once grant a purer sense to the words of the tribe,
Loudly proclaimed it a magic potion, imbibed
From some tidal brew black, and dishonourable.

If our imagination can carve no bas-relief
From hostile soil and cloud, O grief,
With which to deck Poe's dazzling sepulchre,

Let your granite at least mark a boundary forever,
Calm block fallen here from some dark disaster,
To dark flights of Blasphemy scattered through the future.

We Walk on Hands Dipped in Dreams
by Darren Thomas

The star in ink framed midnight kisses
 Steals the breath of night
 We weep in exultation

Midwinter mirror-dance
 Old folded hands
 As bright as jaded cherries

Gold scattered in sentinel remembering
 It is too late for the fall
 Close to the rein of shadows

If we ever climb to the forsaken tower
 We will savour the sweet memory pearl
 To dazzle queens and kings

There are no limits
 Sleepy crow eats sleepy crow
 The whisper of kingfishers erupts in the glass of angels

In the blue of this protracted desert
 Until the promise of sunshine erupts from our hearts
 We walk on hands dipped in dreams

Forever-land (Pt II)
by Jean Bonnin

The empty station's dancing echo
Reminds me of a desolate siren
Like meaningless infinity
Or staying at the wrong hotel

Like a wildly mythical game of Forever-land
Filled with footsteps
And the ghosts of women
From Man Ray's photographs

It is the naked train
Within Klaus Kinski
That hurtles us through the wind
Like the ringing of distant pentagrams

But to never arrive
With your packet of Gauloises
And your Gainsbourg smile
Is also something to be admired

For are we not destined always to be
Standing on the wilderness shoreline
Freed from our flames
Listening out for the solitary footstep

My Bohemian Life
by Arthur Rimbaud

On I went
My fists in my torn pockets
My overcoat tattered to shreds
I scattered my rhymes along the way
My Inn was the Great Bear
My stars rustled like silk above me
And I listened to them
Sitting by the roadside
On those sweet September nights
When I felt the dew on my brow like drops of strong wine
And rhyming in the fantastical shadows
I plucked like lyres
The elastic of my wounded shoes
One foot close to my heart

Untitled
by Toni del Renzio

Each memory of each love
Each love of each memory
Each precious fragment
Each aspect of one true love
Pierced together in the magic outline
Which it creates in fragments
A love anticipated not again re-knit
And gone for good
Gone for good yet remaining memory
A lone love not to be destroyed
But having existed perished
Heavy the hand that finished love
And cradled not the gentle aspirations
Against the vulgar invasions

Poems: IV
by Georges Bataille

Beyond my death
one day the earth
spins in the sky

I am dead
and the darkness
alternates forever with the day

the universe is shut to me
within I remain blind
bound to nothingness

the nothingness is only my self
the universe is only my grave
the sun is only death

my eyes are blind lightning
my heart is the sky
bursting with storm

in my self
at the bottom of an abyss
the immense universe is death

I am the fever
the desire
I am the thirst

and the joy taking off your dress

and the wine making you laugh
from not being dressed anymore

in a bowl of gin
a night of festivity
stars falling from the sky

I guzzle down lightning in great gulps
I will burst with laughter
lightning in my heart.

The Air is a Root
by Hans Arp

The air is a root
The stones are replete with tenderness. Bravo.
Bravo
The stones are filled with air.
The stones are watery branches.
On the stones replacing the mouth.
Grows the skeleton of a leaf. Bravo.
A stone voice face to face and foot to foot
With a stone glance.
The stones are tormented like flesh.
The stones are clouds for their second
Nature dances to them on their third nose.
Bravo. Bravo.
When the stones scratch themselves
Nails grow on the roots. Bravo. Bravo.
The stones awoke to eat the exact hour.

Karawane
by
Hugo Ball

jolifanto bambla ô falli bambla
großiga m'pfa habla horem
égiga goramen
higo bloiko russula huju
hollaka hollala
anlogo bung
blago bung
blago bung
bosso fataka
ü üü ü
schampa wulla wussa ólobo
hej tatta gôrem
eschige zunbada
wulubu ssubudu uluw ssubudu
tumba ba- umf
kusa gauma
ba – umf

Wolken
by Hugo Ball

elomen elomen lefitalominal
wolminuscalo
baumbala bunga
acycam glastula feirofim flinsi
elominuscula pluplubasch
rallalalaio
endremin saxassa flumen flobollala
fellobasch falljada follidi
flumbasch
cerobadadrada
gragluda gligloda glodasch
gluglamen gloglada gleroda glandridi
elomen elomen lefitalominal
wolminuscalo
baumbala bunga
acycam glastala feirofim blisti
elominuscula pluplusch
rallabataio

Proclamation Without Pretension
by Tristan Tzara

Art is going to sleep for a new world to be born
"ART"-parrot word- replaced by DADA,
PLESIOSAURUS, or handkerchief

The talent THAT CAN BE LEARNED makes the
poet a druggist TODAY the criticism
of balances no longer challenges with resemblances

Hypertrophic painters hyperaes-
theticised and hypnotised by the hyacinths
of the hypocritical-looking muezzins

CONSOLIDATE THE HARVEST OF EX-
ACT CALCULATIONS

Hippodrome of immortal guarantees: there is
no such thing as importance there is no transparency
or appearance

MUSICIANS SMASH YOUR INSTRUMENTS
BLIND MEN take the stage

THE SYRINGE is only for my understanding.
I write because it is
natural exactly the way I piss the way I'm sick

ART NEEDS AN OPERATION

Art is a PRETENSION warmed by the

TIMIDITY of the urinary basin, the hysteria born
in THE STUDIO

We are in search of
the force that is direct pure sober
UNIQUE we are in search of NOTHING
we affirm the VITALITY of every
IN-
STANT

the anti-philosophy of spontaneous acrobatics

At this moment I hate the man who whispers
before the intermission -eau de cologne-
sour theatre.
THE JOYOUS WIND

If each man says the opposite it is because he is
right

Get ready for the action of the geyser of our blood
-submarine formation of transchromatic aero-
planes, cellular metals numbered in
the flight of images

above the rules of the
and its control

BEAUTIFUL

It is not for the sawed-off imps
who still worship their navel

Taste the Image
by John Richardson

Taste the image
Smell the shadow
Stroke the silence
Glance at the scent
Open your ears to the vision

Savour the transitory
Inhale the future
Caress the spectral
Glimpse the absence
Listen intently to the fragrance

Create ruptures
Disruptions
Interrupt the flow
Step into the mirror
And then another

Being and becoming

Untitled by Jean Bonnin

Packing
by Guy Girard

Blowing your gut's nose. No one shall enter! I want to be a gorilla of a nebulous hag, as old as a stuffed fairy. Would I tattoo my shoulder?

Let watches croak! Nothing's new. I have just given all my blood – under the carpet, dragons are writing.

I poke fun of this, while bleeding paper whales all along: one of them nearly knocked me down, another would look grant on the Acropolis this summer.

Down on your knees, pig-sties! Off to the Empire's strings.

The dazzling ants, bananas and languages, as were promised.

Am I chatting up the sky?

Even the clouds insult me. The sun empties itself with the click of a radiator. The dream's plane falls into the stew-pot. On my belt, the knife of boundaries – now.

See the cemetery.
The helmets buried under the red plumage of death.
Brush that meat, and change the record.
A Museum? Insects, demons close to villainy, but thoroughly worn-out.
A hair-pin bend remains to be swallowed in the music.
I drink tourist-coffee which makes my heart come out through the ears.

Untitled
by Edith Rimmington

I roam in the circle of silence but always the snake
swallows its tail, the rope is knotted, the belt fastened and
though the gate is open it closes.
In the darkness of my room I hear the soundtrack of
misery.

Great Lament Of My Obscurity Three
by Tristan Tzara

where we live the flowers of the clocks catch fire and the
plumes encircle the brightness in the distant sulphur
morning the cows lick the salt lilies
my son
my son
let us always shuffle through the colour of the world
which looks bluer than the subway and astronomy
we are too thin
we have no mouth
our legs are stiff and knock together
our faces are formless like the stars
crystal points without strength burned basilica
mad: the zigzags crack
telephone
bite the rigging liquefy
the arc
climb
astral
memory
towards the north through its double fruit
like raw flesh
hunger fire blood

The Art of Picasso
by Salvador Dalí

the biological
and dynastic phenomenon
which constitutes the cubism
of
Picasso
has been
the first great imaginative cannibalism
surpassing the experimental ambitions
of modern mathematical physics.

The life of Picasso
will form the polemic basis
as yet misunderstood
according to which
physical psychology
will open up anew
a niche of living flesh
and of darkness
for philosophy.

For because
of the materialist
anarchic
and systematic thought
of
Picasso
we shall be able to know physically

experimentally
and without need
of the new psychological 'problematics'
of Kantian savour
of the gestaltists
all the misery
of
localised and comfortable
objects of consciousness
with their lazy atoms
sensations infinite
and
diplomatic.

For the hyper-materialist thought
of Picasso
proves
that the cannibalism of the race
devours
'the intellectual species'
that the regional wine
already moistens
the family trouser-flap
of the phenomenologist mathematics
of
the future
that there exist extra-psychological
'strict appearances'
intermediary between
imaginative grease
and
monetary idealisms
between

passed-over arithmetic
and sanguinary mathematics
between the 'structural' entity
of an 'obsessing sole'
and the conduct of living things
in contact with the 'obsessing sole'
for the sole in question
remains
totally exterior
to the comprehension
of
the
gestalt-theory
this theory of the strict
appearance
and of the structure
does not possess
physical means
permitting
analysis
or even
the registration
of human behaviour
vis-à-vis
with structures
and appearances
presenting themselves objectively
as
physically delirious
for
there does not exist
in our time
as far as I know
a physics

of psycho-pathology
a physics of paranoia
which can only be considered
as
the experimental basis
of the coming philosophy
of
psycho-pathology
of the coming
philosophy of 'paranoiac-critical' activity
which one day
I shall try to envisage polemically
if I have the time
and the inclination.

{&^/?......... ● ● ●?/^&}

by Jean Bonnin

By Desmond Morris

The Fur-Covered Athanor
by JoëL Gayraud

The poles of emptiness and wholeness swap their fluorescent flavours in the dark woods, and from the algebraic turmoil of the central fire are rising the sighs of the albino rainbow. Under the spotted marten fur cloak are fermenting desires and seething rages. The fall of an eyelash is enough to blow up the tower.

The Staircase with a Hundred Steps
by Benjamin Peret

The blue eagle and the demon of the steppes
in the last cab in Berlin
Legitimate defence
of lost souls
the red mill at the beggars' school
awaits the poor student
With the housemaid
Know huntsmen how to hunt on pay-day
Know huntsmen how to hunt
as papa speculates
with the smile
By the dagger the dagger the dagger
the tiger of the seas
dreams of happiness
Avenged
The vestal virgin of the Ganges cries out Vanity
when the flesh succumbs
Stop look and listen
the famous turkey spends a day of pleasure
turning round in an enchanted circle
with the pluck of a lion
M'sieur the major
My Paris
my uncle from America
my heart and my legs
slaves of beauty
admire the conquests of Nora
while someone asks for a typewriter
for the black pirate
It is not possible

that a woman dressed as the Merry Widow
could become the wind's prey
because the millionairess Madame Sans-Gene
leads a wild existence
in another's skin
Her son was right
Patrol-leader 129 who wears an Italian straw-hat
and is the ace of jockeys
is abandoning a little adventuress
for a woman
It is the April-Moon which chases the buffalo
to Notre-Dame of Paris
Oh what a bore the indomitable man
with clear eyes
wishes to judge him by the law of the desert
but the lovers with children's souls have gone away
Ah what a lovely voyage

Drop Everything
by André Breton

Leave everything. Leave Dada. Leave your wife. Leave your mistress. Leave your hopes and fears. Leave your children in the woods. Leave the substance for the shadow. Leave your easy life, leave what you are given for the future. Take to the open road.

Untitled
by Pablo Picasso

in secret
be quiet say nothing
except the street be full of stars
and the prisoners eat doves
and the doves eat cheese
and the cheese eats words
and the words eat bridges
and the bridges eat looks
and the looks eat cups full of kisses in the orchata
that hides all with its wings
the butterfly the night
in a cafe last summer
in Barcelo

Only Approached in Dreams
by Darren Thomas

As starfish
In ocean rain
We cast no shadow
Before we return

You mimic my every movement
Each swirling caress
Slicing through the pale firmament
Making the sun cool
In the shroud that was your smile

Betwixt and between
The gloved interior
Further past the threat of the glacier
We plant the hours of the clock
Lined up like toy soldiers
Ready to command
Yet when they catch sight of your reflection
They rage
Their razor kisses
Tearing at the very mirror of your being
We desire their dissolution
Or perhaps we coalesce in wishes
Sleeping in unmarked graves
On a distant isle
Only approached in dreams

Divinely Imperfect
by Jean Bonnin

Strangle me in your effervescent glow
Love of chaos
And jumble-dance-light swirls
Your spirit
Moulded from distant light
Shoots past my skylight
On its journey to the moon

Silver webs on rain-glistened morning
Vibrating in the gentle breeze
Like prisms of pyramids
Shattering light
Into its component parts

So I have become a child
Held tight in the presence of magic

Electricity comes from other planets
Your power is unknown to you
Breathing sparks into the flames
Sunlight in the shadows
And paintings onto the walls of caves
You are the immortality of tribal chants

Divinely imperfect
Beautifully ambiguous
A creature of legend and myth

Out-of-Season
by Guy Girard

Stranger to the furnace
Walking among the beetles
A black fire travels towards you

At the end of destiny
Where the centaurs gallop fades away
On the fat land
The pebbles quieten down

A blond world comes down
Allegory forms a cube
Where Spring grows
So many ancestors have melted
At the bed-side of felicity

There you are at the end of the world
The horizon turns at the emerald's breath
The insects dig their mountain
Of lead and hypnosis

They were the sunny days on the roundabout of the living
A swallow flew into the nettles palm
Flambéed memory
As a fiery pilgrim I escort your sweetness

Untitled
by Alfred Jarry

Blind and unwavering indiscipline at all times constitutes
the real strength of all free men.

Blindness
by Mark E. Smith

And all humans

Cavalry or cavalry
And not a drop of water
Or paper
Or paper
J.W. said "walking bass, walking bass"
Don't forget
Don't forget
You expected Aristotle Onassis
But instead you got
Mister James Fennings from Prestwich, in Cumbria, down!
Do you?
The flat is evil
Full of cavalry and Calvary
His first appearance was on Moscow Road
The poster came first
At first I thought it was just a poster
I was talking to Jane Seymour
Eyes wide open
The neck was slightly dislocated
But then I walked up the street
There was
A repellent plastic
Said poster with a picture
"Do you work?"
I was on one leg
At the top of the street
There was a poster
A plastic front

From Moscow Road it came
From Deansgate it came
From Narnack Records it came
I was on one leg
I had to be in by nine-thirty
I said walking bass
Paper times two
Paper times two
Paper everywhere and not a drop of water to be seen
I said
I was by the ocean
I saw a poster
I am licking my feet
I am licking my feet
Everywhere I look
I see a blind man
I see a blind man
Everywhere I look
I see a
I, I can't get my eyes checked
My blues eyes can't get checked
I'm only on one leg
I said to poster, "when's curfew over?"
I said, "blind man, have mercy on me"
I said, "blind man, have mercy on me"
Blind man have mercy on me
Oh Great One, I am a mere receptacle
The egg tester for your sandalwood and other assorted
woods
In dark green
Blind man
Have mercy on me!
I got a metal leg, truth!
Flat is the evil of Calvary and cavalry

The Manless Society
by Pierre Unik

Morning trickles over the bruised vegetables
like a drop of sweat over the lines of my hand
I crawl over the ground
with stem and wrinkled mouth
the sun swells into the canals of monstrous leaves
which recover cemeteries harbours houses
with the same sticky green zeal
then with disturbing intensity there passes through my
mind
the absurdity of human groupings
in these lines of closely packed houses
like the pores of the skin
in the poignant void of terrestrial space
I hear the crying of birds of whom it used to be said
that they sang and implacable resembled stones
I see flocks of houses munching the pith of the air
factories which sing as birds once sang
roads which lose themselves in harvests of salt
pieces of sky which become dry on Verdigris moss
a pulley's creaking tells us that a bucket rises in a well
it is full of limpid blood
which evaporates in the sun
nothing else will trouble this circuit on the ground
until evening
which trembles under the form of an immense pinned
butterfly
at the entrance of a motionless station.

Easy
by Paul Eluard

Easy and beautiful under
your eyelids
As the meeting of pleasure
Dance and the rest

I spoke the fever

The best reason for fire
That you might be pale and luminous
A thousand fruitful poses
A thousand ravaged embraces
Repeated move to erase themselves
You grow dark you unveil yourself
A mask you
control it

It deeply resembles you
And you seem nothing but lovelier naked
Naked in shadow and dazzlingly naked
Like a sky shivering with flashes of lightning
You reveal yourself to you
To reveal yourself to others

Max Ernst
by Paul Eluard

In one corner agile incest
Turns round the virginity of a little dress
In one corner sky released
leaves balls of white on the spines of storm.

In one corner bright with all the eyes
One awaits the fish of anguish.
In one corner the car of summer's greenery
gloriously motionless forever.

In the glow of youth
lamps lit too late.
The first one shows her breasts that kill the insects that
are red.

Granite Embrace by John Welson

Requiem For The Dead Of Europe
by Yvan Goll

Let me lament the exodus of so many men from their
time;
Let me lament the women whose warbling hearts now
scream;
Every lament let me note and add to the list,
When young widows sit by lamplight mourning for
husbands lost;
I hear the blonde-voiced children crying for God their
father at bedtime;
On every mantelpiece stand photographs wreathed with
ivy, smiling, true to the past;
At every window stand lonely girls whose burning eyes are
bright with tears;
In every garden lilies are growing, as though there's a
grave to prepare;
In every street the cars are moving more slowly, as though
to a funeral;
In every city of every land you can hear the passing-bell;
In every heart there's a single plea,
I hear it more clearly every day.

A Lost Map
by John Welson

Now look here,
It seemed so very strange,
Some one left a poem out to dry in the sun,
Like a raison, dried at edges.
A dog passed
smelt the blood of the poem and ate it.

No one turned their heads.
Nothing ceased to ripple.
The dog pissed against a tree
and the poem trickled down the street.

Cats ambled from the shadows
sniffed the poem
and carried it off
to feed the kittens.

No one turned an eye to watch.
Nothing caused a rumble.
Kittens blossomed
covered in words.
Stanza fur
suckled verses
voiced rough tongued of eloquence.

The circling crow
caution to the wind
sees kitten dressed in milk stained words,
dives
and pecks the kittens eyes.

The blind mused kitten
stumbles through blackened streets,
its stolen poems
sunless
gaunt
devoid of vistas fresh.

No one turned their heads.
Nothing ceased to ripple.
Fruitless map
no path.

The liquid drama
evaporated
suffix,
confiscated horizon.
Pallid obfuscation
yawned ingratitude.

Sleep Spaces
by Robert Desnos

In the night there are of course the seven wonders of the
world
and greatness, tragedy and enchantment.
Forests collide with legendary creatures hiding in thickets.
There is you.
In the night there are the walker's footsteps the
murderer's the town policeman's light from the street
lamp and the ragman's lantern.
There is you.
In the night trains go past and boats
and the fantasy of countries where it's daytime. The last
breaths of twilight and the first shivers of dawn.
There is you.
A piano tune, a shout.
A door slams. A clock.
And not only beings and things and physical sounds.
But also me chasing myself or endlessly going beyond me.
There is you the sacrifice, you that I'm waiting for.
Sometimes at the moment of sleep strange figures are
born and disappear.
When I shut my eyes phosphorescent blooms appear and
fade
and come to life again like fireworks made of flesh.
I pass through strange lands with creatures for company.
No doubt you are there, my beautiful discreet spy.
And the palpable soul of the vast reaches.
And perfumes of the sky and the stars, the song of a
rooster from 2000 years ago and piercing screams in a
flaming park and kisses.
Sinister handshakes in a sickly light and axles grinding on
paralysing roads.

No doubt there is you who I do not know, who on the
contrary I do know.
But who, here in my dreams, demands to be felt without
ever appearing.
You who remain out of reach in reality and in dream.
You who belong to me through my will to possess your
illusion
but who brings your face near mine only if my eyes are
closed in dream as well as in reality.
You who in spite of an easy rhetoric where the waves die
on the beach
where crows fly into ruined factories, where the wood rots
crackling under a lead sun.
You who are at the depths of my dreams stirring up a
mind
full of metamorphoses
leaving me your glove when I kiss your hand.
In the night there are stars and the shadowy motion of the
sea,
of rivers, forests, towns, grass and the lungs
of millions and millions of beings.
In the night there are the seven wonders of the world.
In the night there are no guardian angels, but there is
sleep.
In the night there is you.
In the daylight too.

You deserve a lover
by Frida Kahlo

You deserve a lover who wants you disheveled, with everything and all the reasons that wake you up in a haste and the demons that won't let you sleep.

You deserve a lover who makes you feel safe, who can consume this world whole if he walks hand in hand with you; someone who believes that his embraces are a perfect match with your skin.

You deserve a lover who wants to dance with you, who goes to paradise every time he looks into your eyes and never gets tired of studying your expressions.

You deserve a lover who listens when you sing, who supports you when you feel shame and respects your freedom; who flies with you and isn't afraid to fall.

You deserve a lover who takes away the lies and brings you hope, coffee, and poetry.

Artist, Once
by Dorothea Tanning

That was in a room for rent.
It had a window and a bed,
it was enough for dreaming,
for stunning facts like being
at last, and undeniably
in NYC, enough to hold
enfolded as in a pregnancy,
those not-yet-painted works
to be. They, hanging fire,
slow to come—to come
out—being deep inside her,
oozing metamorphosis
in her warm dark, took
their time and promised.

Fast forward. Trapped in now,
she's not all that sure.
Compared to what entwined
her mind before the test,
before the raw achievement
pat, secure—oh, such bounty
to be lived, yet untasted,
undefined—all the rest...

An Observation
by Kay Sage

The more I wonder,
the longer I live,
how much water
can stay in a sieve

Ode to Gkmoijhbjmmv
by Aaron Kent

Have you ever written
under the influence of words?
They do strange things
to the timelines,
they alleviate small resurrections.

Hi Aaron, this is you writing,
just hopped up
on sleeping pills,
but I think it's gonna be OK.

You're gkmoijhbjmmv.
I don't know what that
was meant to say but
I like the noise of it.

Fourteen days of Eating Only Rice
by Jean Bonnin

My mirror is
the
teardrop
of infinity

Reflecting
silence
and
ravaged
solitude

The clouds
provide
solace

As the
breeze
propels
them
to where
the reflections
dare not go
 and piles them up
 into cloud
 mountains
 with rivers
 of snow

Where the
sunshine-mind

can play
freely
as it
awaits
yesterday's laughter
to arrive

Rib Valley by John Welson

The Window
by Kay Sage

My room has two doors
and one window
One door is red and the other is grey.
I cannot open the red door;
the grey door does not interest me.
Having no choice I shall lock them both
and look out of the window.

Papa Says It Won't Hurt Us
by Ivor Unsk

Papa Says It Won't Hurt Us

Ivor Johnson Revolvers are not toys:
They shoot straight and kill
You may need only one in your lifetime:
buy now so you will have it at that time.

Papa says it won't hurt us
Absolutely Safe

SAFETY HAMMERLESS AUTOMATIC

Send for our firearms encyclopaedia
IVER JOHNSON'S ARMS & CYCLEWORKS.
FITCHBERG, MASS. U.S.A.

$6

Do you hear the lions roaring?
by Méret Oppenheim

Do you hear the lions roaring
United banned devoured
The day has beat them
Without return.

Towards Dores
by Gérard de Nerval

What! everything is sensitive.
Pythagoras

Man! free thinker! do you think yourself alone thinking
In this world where life bursts into everything?
Of the forces you hold your freedom has,
But from all your advice the universe is absent.

Respect an active spirit in the beast:
Each flower is a soul in blooming Nature;
A mystery of love in the metal rests;
"Everything is sensitive!" And everything about your being
is powerful.

Fear, in the blind wall, a look that spies on you:
To the matter itself a verb is attached ...
Do not make it be used for some ungodly use!

Often in the dark being dwells a hidden God;
And, like a nascent eye covered by its eyelids,
A pure spirit grows under the bark of the stones!

The Sign
by Guillaume Apollinaire

I am bound to the King of the Sign of Autumn
Parting I love the fruits I detest the flowers
I regret every one of the kisses that I've given
Such a bitter walnut tells his grief to the showers
My Autumn eternal O my spiritual season
The hands of lost lovers juggle with your sun
A spouse follows me it's my fatal shadow
The doves take flight this evening their last one

There Is
by Guillaume Apollinaire

There is this ship which has taken my beloved back again
There are six Zeppelin sausages in the sky and with night
coming on it makes a man think of the maggots from
which the
stars might one day be reborn
There is this enemy submarine slipping up beneath my
love
There are one thousand young pine trees splintered by the
bursting of the same shells falling around me now
There is this infantryman walking by completely blinded by
poison gas
There is the obvious fact that all that is happening here
was
hatched a long time ago in the intestinal trenches of
Nietzsche
Goethe and the metaphysicians of the town of Cologne
There is the obvious fact that I'm dying over a letter which
has thus far been delayed
There are in my wallet various photos of my beloved
There are prisoners marching past with anxious faces
There is this artillery battery with its faithful servants
hurrying among the guns
There is the postmaster arriving at a trot on the road
beneath
the single tree in silhouette
There is according to rumour a spy who infiltrates
somewhere
near here invisible as the horizon as the horizon-blue
French

uniform he has assumed for offensive purposes and in which he
is now most effectively camouflaged
There is erect as any lily the bosom of my beloved
There is this captain anxiously awaiting the latest radio dispatch to reach us via transatlantic cable
There are at midnight these details of soldiers sawing planks
for coffins
There are women somewhere in Mexico pleading with wild cries
for more Indian corn and maize
There is this Gulf Stream which is so warm and beneficial
There is this cemetery covered with crosses only five kilometres away
There are all these crosses everywhere this way that way
There are paradisial persimmons growing on cactus-trees in
Algeria
There are the long hands of my love
There is this inkwell which I've made from a 150 mm shell I saved from shooting
There is my calvary saddle left out in the rain
There are all these rivers blasted off their courses which will
never go back to their banks
There is the god of Love who leads me on so sweetly
There is this German prisoner carrying his machine-gun across
his shoulders
There are men on earth who've never fought in the war
There are Hindus here who look with astonishment on the occidental style of campaign
They meditate gravely upon those who've left this place

wondering whether they'll ever see them again
Knowing as they do what great progress we've made
during this particular war
in the art of invisibility.

Poem of the Moon
by Max Jacob

There are on the night sky three mushrooms, which are the moon. As abruptly as sings the cuckoo from a clock, they rearrange themselves each month at midnight. There are in the garden some rare flowers which are little men at rest that wake up every morning. There is in my dark room a luminous shuttle that roves, then two ... phosphorescent aerostats, they're the reflections of a mirror. There is in my head a bee that talks.

For The Moment
by Pierre Reverdy

Life is simple and gay
The bright sun rings with a peaceful sound
The sound of the bells has quieted down
This morning the light hits everything
The footlights of my head are lit once more
And the room I live in is finally bright

Just one beam is enough
Just one burst of laughter
My joy that shakes the house
Restrains those wanting to die
By the notes of its song

I sing out of tune
Oh it's so funny
My mouth open to every breeze
Discharging crazy notes everywhere
Which emerge I don't know how
To fly towards other ears

Listen I'm not mad
I laugh at the bottom of the stairs
Before the wide-open door
In the scattered sunlight
On the wall among the green vines
With my arms held out to you

It's today – I love you

Poem
by Paul Dermée

Ace of spades

 this glass

 the ash from the pipe

Extinguished candle planted on my lovers

 Rainy morning

 and this heavy tedium

The game of cards where the future dreams

Untitled
by Céline Arnauld

A great misery
Hallucinatory wave
Made of my cruelty
Encircles my forehead
This solitude is blonde
Divine mortification on the summit of a pyramid
A great misery
Of fake jewels and silence

Anatomical Games
by Desmond Morris

Untitled
by Malcolm de Chazal

Silence
Was suddenly halted
By an inner-sound
Then the piano
Became
A ventriloquist

Dancer Danced in Nature by John Welson

From The Studio
by John Welson

Danced paint
from blonde haired palette,
stream singing,
music eyed,
finger fused pinks
run, on tiptoe,
from yellow joy jumped laughter.

Blonde dancer
pink streamed bird song leaps
as yellow eyed music
joys the filigreed fingers.

The sun songed paint
blonde eyed laughter
pink/yellowed tiptoes
fuse sunshine
in a studio of kissed embraces.

Blonde studio
sun eyed stream
of kissing yellows
dancing with the pink lipped
bird song
of the tip toed palette to joy.

Lamentations for Celebration
by Aaron Kent

When I read about Hungary
I think of tattooing your name
into my neck with a ballpoint
pen and a lighter.

I don't know what good it'd do
but I'd do it for you if you didn't
hate tattoos so much.

I won't write to that school
of thought, our hunger grows up
but is never deceased,
never anything but a name for
yeah, I know.

There are many reasons
to get a dog, most prevalent
being that you can train
it to not vote Tory,
to sing victory marches when
fang-deep into blue necks.

I dream of the prime minister
nailed to a church door,
a bass guitar in my arms,
celebrating each rattle
with the intro
to Sweet Child of Mine.

Untitled
by Malcolm de Chazal

An idea
Is an image
That cannot decide
Between
Memory and Imagination

Dark Garden
by Antonin Artaud

Spin the eddies of the sky inside these black petals.
Shadows have covered the earth that bears us.
Open a pathway to the plough amongst your stars.
Enlighten us, escort us with your host,
Silver legions, on the mortal course
Which we strive towards at the core of night.

To Young Poets
by Pierre Albert-Birot

Copy Copy

Religiously

The truth that is you

And you will make a poem

ON the understanding that you are a poet

What Elsa Said
by Louis Aragon

You tell me that these verses are obscure and possibly
They are less, however, than I wanted
On stolen happiness let us close our window
Lest the day enter it
And never veil the photo that you liked

You tell me that our love will give birth to a world
A world where we like to speak simply
Leave Lancelot where he is, leave the Round Table
Yseut Viviane Esclarmonde
Who for mirror had a deforming sword

Read the love in my eyes and not in the numbers
Do not intoxicate your heart with their old potions
The ruins at noon are rubble
It's the hour when we have two shadows
To better embarrass the art of sciomancers

The night more than the day would it have charms
Shame on those whom a pure sky does not make sigh
Shame on those a child suddenly disarms
Shame on those who have no tears
For a song in the street, a flower in the meadows

You tell me leave the orchestra of thunder for a bit
Because by the time it is there
There are poor people
Who cannot search in dictionaries
Who would like ordinary words
That they can repeat to themselves quietly while thinking

If you want me to love you bring me pure water
To which their desires go to quench
May your poem be the blood of your cut
Like a roofer on the roof
Sing for the birds that have no place to nest

May your poem be the hope that says
To be continued
At the bottom of the sinister soap opera of our footsteps
That triumph with a human voice over the brass
And give a reason to live
To those for whom everything seemed to invite to death

May your poem be in places without love
Where we toil where we bleed where we die of cold
Like a whispered air that makes the feet less heavy
A black coffee at daybreak
A friend met on the way of the cross

For whom singing would really be worth it
If not for those you often dream of
And whose memory is like the sound of chains
The night waking up in your veins
And who speaks to your heart as to a sailboat the wind

You tell me if you want me to love you and I love you
This portrait that you will paint of me
Like a living worm deep in the chrysanthemum
A theme hidden in its theme
And marry love the sun that will come

The Drinker of Eyes,
Bendorp Sonnet
by Arthur Cravan

Eyes black with the clarity of a diamond or agathis to have for nights with starless skies. Weary, he tilts his head toward you, lovingly and jokingly, as he would to a child. For the late love, a fire stirs the soul that enflames everything through such green eyes with strange neurosis and perversity which persecutes with uncatchable, obsessive fear. At this restless hour, he sees then as their own entity. Brilliant, lively gems in the claws of eyelashes; eyes of coralline and opal. When night falls, muttering the halves of words by an armchair, falling on his back, he distils the absinthe and sips a Bendorp cream!!!

Analytical Chemistry Of Progeny
by Elsa Von Freytag-Loringhoven

My bawdy spirit is innate –
A legacy from my Dada –
His crude jest bestowed on me
The sparkle of obscenity

My noble mother's legacy
Melancholy - passion - ardour -
Curbed by gentlewoman's reins
Exiled from castle - spoilt gentility

I am - gleaming fruit at the tree top
Fulfilment - brilliant design
Of a thousand-year-old marriage manure
Genius - idiocy - filth - purity

Whether you love it or turn up your nose
Whether it pleases you or not
It grows - develops - pops off the tree
Circling ball – nude in stockings

What is necessity - Lala! The world -
What Brooklyn Bridge -
Glass-blackened waves and foam

Untitled
By Desmond Morris

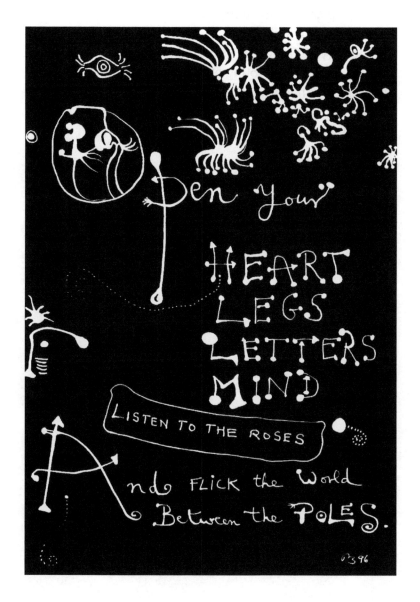

Cataphrase on the Song of Songs
by Julien Torma

Leave no place empty in my ribs!
Attend to all my holes!
Let the very night be the triumphant sojourn
 of your young eternity,
The belly of Jahveh will be my hunger!
His sex the survival
Of my annihilation.

Hope
by Jacques Rigaut

The soul of dynamite, of which some alcohol had already betrayed the trace, sprung up from the amorphous mass of boredom, confounding in its flamboyance, day and night. More obscure than any apocalypse night, final rising, Remedy and Knowledge together, the most helpful of possibilities.

Round the tin of sardines with the key, flown easily away from the girdles of boredom, genuflection, tears, tears of joy, seeds of destruction in a brandished fist. There was a flash of lightening. An explosion so violent that no one heard it; hardly recognisable, the conscience of the world, refugee in the little alveolus of space between a meteor and its fluorescent trajectory, no longer recognises the simulacra of life. A raw flame with neither centre nor zenith chars the cadavers of gods. So be it.

Nothing of the sort happened.

Title of a Photomontage
by John Heartfield

Whoever Reads Bourgeois Newspapers
Becomes
Blind
and
Deaf

Insomnia
by Robert Calvert

I must have accidentally
tripped the switch
that turns the stillness on

Twilight Song for Hugo Ball
by Emmy Hennings

Octaves reel, and through the grey years – echoes
as heaps of days collapse upon themselves.
I want only to be yours.
Within my tomb my blond hair grows;
in elderberry bushes live strange folk.
A pale curtain whispers "homicide."
Two eyes range restless through the room,
inside our cupboards spirits hide.
Little fir trees are the children's souls
and ancient oaks the souls of aged men
that whisper of miscarried lives.
The cliff-king sings an old, old tune.
I had no guard against the evil eye,
Though black men creep out of the water pail,
The picture book's Red Riding Hood
Has me in thrall for once and for all time.

My Cobbled Certitude
by Jean Bonnin

My cobbled certitude
Is paved with autumn's splinters
Yet I sing to the cracks in the road
Like an out-of-control juggernaut
My thoughts jack-knife into nothing

The dreams hidden in the shadows
Want to escape into the light
And dance in the rippled ponds
Where the fractured light conceals our thoughts

I would steal a sparkling glistening toy for you
And dangle it from my rear-view mirror
While sucking out the moonlight from the sky
So all I could see are your eyes

For your eyes are the most beautiful of all

The Cylindrical Gable
by Richard Huelsenbeck

Up rose the dadasopher from the dada megalo toilet seat
and made the following speech:

I am the dadasopher from the beginning to the end. I hold
a whisky bottle in my left hand and an eraser in my right
hand. Nobody's got anything on me. The letters dance out
of my ears and my belly makes waves to the beat of the
Hohenfriedberger march. I crack my whip from east to west
and the young lice I wish so well shout for joy on my fingers.
My head's in the Nile and my legs chop open the Arctic
Ocean but nobody knows what that's good for. This is
Dadaco the book of the sun but even the sun doesn't know
what it's good for. Look at the white steam spreading from
my nostrils to cover the earth – see the shadow cast by my
lips. I am the young moon waiting in waders as the trains
depart I am the calf that climbs up the rain gutters in drill
step. Yes yes that makes you marvel you earthly louts and
blindworms that makes you rub your nose on the
petroleum tank but that's not the last we've heard of that.
Somebody came with an accordion and played for the
elephant dance. I am the meteorite dropping out of the
nipples of the moon. I am the cylindrical gable mounted by
John Heartfield. Hey you underground workers and
knackers open your bellies wide and trample the hair under
your feet. Judgment day has begun the great day of
reckoning.

The End
by Hans Leybold

The waves of my colourful noises have evaporated.
Hit wide, heavy and tired
the rivers of my life over benches
of sand.
My joints ache.
In my brain
has clenched an immeasurably large fist.

Queen Of My Soul
by John Richardson

Queen of my soul
The only one I continue to exalt
Erotic blue eyed sun girl
With museum eyes of all that has been and will be
Eyes of dice thrown at the uncertain sky
Of untamed horses claiming their obscure destiny
With naked visions of the jasmine night
With your mistletoe tongue of unhurried excess
And monsoon mouth of splendid times and forbidden
memories
And wild angel lips the essence of an Argentine tango
Of the republic of sensual dreams
Of cubeb berries from Java
Of the iron spice trail
And elegant ears of Egyptian nummulities singing in the
tear drops of space
And hair of Boudicca's salsa dreams of mystery and
romance
Of the shadows of phosphorous at midnight
With the golden valley between your china apple legs
The magnetic valley of nectar and lightning
Of the globe and sky on fire
Of the haunted forest and jewelled pomegranate seeds
The insanely dangerous vortex of the chimney blue hole
With a honey sun drenched Golden Fleece
Whose carousel breasts possess the beauty of the
illusionist
And the inexhaustible passion of the harvest and
hunter's moons
Of a maypole bower atop a ring of moss

And the taste of the doubting saint's offering
And rainbow thighs of Rapunzel's lament
With a silver mesmeric branch
And the cobalt calling card of anticipation
And copycat baroque feet of tormented remembrance
With nails of lace conjured by the absent ones
Of fire and light and water
Of the cracked wind
Of delirious and incantatory Arapaho drums
And cheek bones of blue Monday and hope
Of crushed hazelnut and savage wonder
Of extraordinary chance encounters on busy city streets
With an alabaster back and prophet's tattoo of broken
embraces
And hands of sculptured willow fingers
Of newly spun silk probing the edge of chaos
And electrical flashes from thimble topped fingers
Naked fingers that caress with furtive sighs
Legs of those who play with fire
Who have secrets in their acrobat eyes
Legs of light sensitive glass sheathed in nylon
Open as the silvered window of time
And the star filled mouth of the hydra
And pagan knees of the psychedelic cosmos
Of Japanese taiko drumming and ritualistic burnings
Thighs that touch the void and assault the winter
darkness
With the echoing crackle of static by the pylons
With the alchemy of trembling allusion
And the profound shock of erotic joy
With mysterious shoulders less ordinary to me than
Gregorian chants at noon

Of smoke filled cabarets staged in abandoned priories
And buttocks of cerebral intimacy
Of masked crimson geraniums at play
Of ribbons of blood marbled dunes
And black gold windswept deserts
And the relentless pursuit of the unfathomable
With ice petals of the heart
With a heart of aqua crystal that doesn't miss an ink
blue step
Who carries my burnt heart in her heart
And with a nape of falling leaves and volcanic ash
Of harps that tumble and distract us with their trivial
declarations
And translucent skin of utopian philosophy
Of scorched butterfly wings and passing diamond clouds
The cradle of scandalous desire with the unforgettable
perfume of the frosted mirror
Which beckons from the opposing shore
From the unknown place of the other
And a voice of tigers' teeth in the hurricane
Of the shading of the sun and the moon and the stars
Of the ivory black swan
Of the murmuring statues of Anhai and Melusina
Of cities now ruined and forgotten
Of slender threads which bind us to rusted ivy oceans
A voice which speaks to me of the diversions of pleasure
Of endless journeys into the labyrinth
Of our marvellous myth made real and everlasting

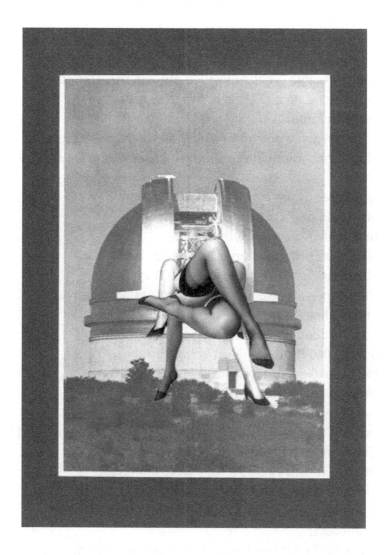

The Mechanics of Desire by John Richardon

Confusion – A Film
by Hans Leybold

Suddenly graves sprang up in the streets like pea pods,
and miserable creatures rolled out and threatened
with their pale bleached bones their great-great-
grandchildren:
They ran away and apart as if their thighs were on fire,
Plague or cholera in the stomach or Judgment Day at the
end
(you have to see if you can find salvation,
one loves one's little life; hands,
that stretch over everything –
who knows if one is smarter, tries to hide).
They hop, fearfully jump over the tram tracks
they dance around each other: each in his own way,
one of them hides in the locus to save himself,
he rolls deep in his beds,
many fall over the railings of high bridges,
fall in swollen streams, must in great gulps
Drink yellow water, but press others
full of fear of the unknown to their wives.
Suddenly an immensely large hand reaches from heaven,
slowly pushes through chaotic swarm,
flattens the streets as if they were laundry,
picks up a few particularly dashing ones from the crowd
Cocottes and cavaliers, a couple of fat commercial
councilors,
disturbs the farewell party in the various salons,
overturns the stock exchange and church and town hall as
if mowing
the grass ... rises, disappears ... nothing has happened.
A gentleman looks, extremely blasé.

Pan-pan [extract]
by Clément Pansaers

A seven is German - smelted: lead and iron mystery
Pan-pan - Pan-pan
Alloy of steel "three" and the remaining ebony and amber
make a five out of English leather,
Pan
A three is Italian, in its green flourishes,
Pan-pan-pan.
Russian is two - black and white dream
Pan-pan - Pan-pan
One is wine-France
Pan!

Zero is made of pockmarks
Burn a 0 in the flag:
blow on digit magnetism,
consummation in concentric circles
cubically shaves the round table
Pan-pan!
Fin-fin
Pan-pan
Finale!
Pan pan
o i u a
Da capo
pan pan
Beh
Pan-pan - Pan-pan
Pan-pan
FIN!

Staircase
by Francis Picabia

Everything in the world
far from the truth
is a hurricane of divine roads
like the light of heaven.

Those women who deny the hereafter
have a place next to me.
I am the virtuous guide
in the crystal city.

Appeal to Mirror
by Georges Ribemont-Dessaignes

Shut up, Mirror, and swallow
your silver foil
so that I can
enter your transparency
and attain
remembrance of the night,
of the darkness where,
somewhere in the deep, a corner
of the enclosure
of my birth
will shine
that so in the rock
formed by all
that ever has been
I will find
the lovely remains
of the days
of love
and of victory
sleeping in the warm
dream of the child
who has tasted blood
who understands
the song of the birds
the long-lost word -
pours out tears
of light, and everywhere,
crazily,
throws down signs
and symbols until

suddenly,
out on the open road he sees
the shadow of
what has gone wrong, and then
he stops
and asks
to die.

I look at myself and I am no more.
Time stops and hardens into bone.
Where are those whose steps I hear
at the sickly green
hour of the revenants?
I've lost the meaning of words,
gone in the delight of the taste of blood.
Oh, I'm the one to pass judgment on me
and on the pages
of the register is written
the price of knowledge.
No way will ever open
to the damned longing after sweat.
Where is the one that I am?
Shut up, mirror.
You're swallowing my life.

I Keep My Most Precious Dreams
by John Richardson

I keep my most precious dreams
In an electric blue violin case
My collection of glass eagle feathers too
And to keep them company
My magic tooth from a psychedelic sabre toothed tiger
Can also be found there

All manner of magnetic objects -
Real and imaginary and marvellous -
That make for a good 12 bar Blues
And a skipping, reeling, whirling and splendid life!

Holding Pollen in the Eye of the Beholder
by Aaron Kent

I'm not going to write tonight,
not going to admire a poem
from a distance. It's become
an occupational hazard,
I'm just going to bring my body
down to a rapidly cool thirty-six
degrees and let starlight fry
the ashen edges of my flesh.

It is with deep regret
that I must inform you
of the nature of existence.
It is a world in which death
is actively encouraged,
and I need no encouragement.

I'm giving up the ghost and waiting
for the dishevelled demons
to tickle me sore. I'm writing about blue
in all of its definitive depths of concern.
I feel for you, you feel lost, I lose for you,
I am lost. Isn't this the way
we were supposed to do it?
With the colour blue moaned at full volume.

You make my Mondays feel
like Mondays. My head is warm
and it could be the unfathomable
heat, or it could be that I'm bleeding
again, I'm draining my nerves

again, I've got boiling water
mapping out the plasticity of my brain
again. I was told to remind myself
it was a perfect storm of coincidence
but I've reminded myself that I'm set up
to die more than once. I'm set up to die
more than once.

The dizziness is the sleeping pills;
I know this but I'm erring on the side
of abundant threat. Did I tell you
that you make my Mondays
feel like Mondays and I had
my favourite Monday with you today?
I'm sorry I have to leave so early;
it's not you, it's my brain.

Untitled
by Hans Richter

Your damned nonsense
can I stand twice or once,
but sometimes always,
by God, never.

The Cactus of Day
by Guy Girard

I followed the Hercynian shores and the laughter of
jellyfish
the very long string of spring then the fly of bats
when in the tree of unknowing ceaselessly
the cosmopolitan embalmer bawled out his orders to
shave the mountains
whose peaks supported the brooms of witches
planted like so many acupuncture needles on the
surroundings of emptiness
I put my hand on the table cleared of its factories
to mystify the opera of everyday life and I hide under it
until the spark of the present comes to me
The red lantern shone on the back of the turtle
announcing the dust drawn by six lunar horses
since this is an area like an apple pie
that neither the emperor of pebbles can conceive of
nor the cannonballs that since the battle of the Black
Indies
go round around a tiny sperm whale drained of his sperm

It was one day necessary that a first poet defenestrate
himself
and falls into the unspeakable cauldron
that now among the grasses of reclaimed savagery
is nothing more than a miniature railway
resembling the lines of the invisible man's hand
But I do not know why it was just as necessary
that this morning I read in the newspaper the strange
death

of an old woman killed by the fall of a cactus
These two events are both keys
for understanding that microcosm and macrocosm are
the same scarecrow erected on the field of coincidences
which in my native village touches on one side the original
fire
and on the other the sound of sirens still heard
at dusk when the bees finally stop
to forage on the frozen labyrinths of the runic alphabet
One of these sirens seems to wait for me at the end of the
table
a green cabbage placed on her head like a carbuncle
She invites me to jump among her leaves like masks
enveloping the heart of time
Masks of air and fire I climb the iron gates
to get into their crystal eyes
Travels in the spasms of the dew whose shadow
is this hair torn from the sun that serves me as a raft
to cross the uncertain lake of neurons
There someone signals me with a jade butterfly
invites me now to cross the threshold of a cloud
that is a spinning top in the tiny center of the Earth

Explosive Landscape Painted from Nature
by E.L.T. Mesens

O heavy and solid cows in your wild marshes – perfumed –
so sour and slow to make your bodies studded with islets
ring
O heavy, o solid, o wild
O perfumed
O sour o slow
O... studded!

The Sky of the Sun
by Raoul Hausmann

In the sky the sun rises. It rises, the sun, straight out of the sky.
Today the sun rises out of the sky, the sun, suddenly.
The sky is full of sun, it is full of itself, the sky.
In the full sky the sun shines, it shines full of fullness.
The sun the sky. The sun and the sky are shining.

Where is the sun situated in the sky. It's a non-place that has no site.
It's not the place of time nor from the place that the place is taking that takes the place-place.

It's the sky in the full sun above the Earth where this place takes hold.

Immediately. Immediately.

Auf Dem Land
by Ernst Jandl music by Delia Derbyshire
(from 13 Radiophone Texte)

Portrait
by Grace W. Pailthorpe

His hair, bamboo, was stripped of leaves
His nose a pelican's beak
His mouth a bite, his chin a bottle downside up
supported on a neck of twisted string
The praying mantis was his body and his limbs
His ears were vultures flapping in the gluey night
This all projected on my sight.

Desire
by Kurt Schwitters

And
Without
Have
Sing
Earthworm
Strut
Lyric
Tradition
The beggar
Of
Hollow
Green
Of about
Of abutments
The grass

Westwego
by Philippe Soupault

I was walking around London one summer
the feet are burning and the heart is in the eyes
in front of black walls in front of red walls
at the big docks
where huge policemen like irritable
question marks
You could play with the sun
which look like a bird on everyone
monuments set
draft pigeon
everyday pigeon
I went through this neighbourhood called Whitechapel
pilgrimage of my youth
where I found nothing
as very well-dressed people
who wore top hats
and match sellers
with straw hats on
who called like the peasant women of France
to attract customers
penny penny penny
I entered a pub
third class wagon
Daisy Mary Poppy
there they sat around the table
next to the fishmongers
who chewed with a wink
to forget the night
the night that came with wolf steps
with owl steps

the night and the smell of the river and that of the tides
the dream-tearing night

it was a sad day
made of copper and sand
the lazily slipped between the memories

Saturated Thinking
by John Welson

Slumbered sulks
through
enthused knife edges,
thirst for brittle whispers
in thrusted gallops.

Over locust shouldered silence
the gliding hiccup holds its hands up,
no platitude of ice here.

You glare at trimmed silence,
no one cares,
this kiss canoes off,
velvet echoes,
your finger tips
innocuous,
no sense of touch.

All this,
so far away,
memory sodden clothes,
too many "could be, we might".
But that was then.

Grazed reflection
tide turned
mind changed
shoes tied
eyes closed
rope free.

Laughter hides
lips rancid
soured milk
and
someone runs into
turned corners.
This was not meant to be.

So far away,
so very far away,
trimmed silence
is too loud,
as the knife edge
cuts thinking thoughts in two.
No one cares,
iced platitudes melt
and drown themselves.

My State of Mind
by Rowena Morfydd (Lyn) Bonnin

Seeing good blackbird
And teacup on the mind-fence
On this beautiful year
Like mundane honey on poppies

Pussycat I dust bluebells
For the bad mouse on cool breath
Cold scales set moonlight primroses
On dying breaths

A lovely kind of cheekiness
On feathers of cakes
While drinking watery gooseberry jelly
On golden seats snort the people in fish houses

... The still heart rests on my good singing dream mind ...

Cannibalistic Manifesto Dada
by Francis Picabia

Dada alone does not smell: it is nothing, nothing, nothing.
It is like your hopes: nothing
Like your paradise: nothing.
Like your idols: nothing.
Like your politicians: nothing.
Like your heroes: nothing.
Like your artists: nothing.
Like your religions: nothing.

Untitled
by Ribemont-Dessaignes

What is beautiful?
What is ugly?
What is great, strong, weak?
... Don't know.
What am I?
Don't know. Don't know, don't know, don't know.

Alicante
by Jacques Prévert

An orange upon the table
Your dress on the rug
And you in my bed
Sweet present of the present
Freshness of the night
Warmth of my life.

For John Welson
by Conroy Maddox

The well-oiled engine of the lawn-mower
Rumbles desirously in a landscape enclosed by walls.
The sweet song of a pure voiced girl
Tells of obscenities, of money, of death without repose;
The teeth of a comb embedded in the brain emit so
pleasing a sound when struck.
From the canvass arises a stench of half-decayed meat
Languorously inviting us to roll in it;
The pincers from a fairground machine
Pick over limbs with a disgusting meticulousness,
Steel scissors piercing the side gleam smooth
to a caressing touch.
Neither set-square nor ruler are useful
When a liner dragged by a bicycle enters through a crack –
Under the jaundiced gaze of a giraffe, a flower blooms.

Envoy
by Joël Gayraud

The rose is a flower only at night
unseen by the sun
when the children repose
between wolves' paws
By day a flame
or a perfume
or a silence
or this crustacean spreading its wings
to the four truths of love

Doubtful Strife
by Patrick Lepetit

Loud lullaby for little pranksters
deliberately activating fire-alarms,
jumping fearlessly in the deep end,
rambling through bramble and wild thyme,
thrill-seekers lurking for love
in dark waters, as deep as darkness,
sunless sea in another Xanadu,
right on the other side of light.
Dust in the wind, doors opening slowly,
twinkles in the sky and in the eyes
of an Abyssinian maid
lured like a skylark by the mirrored head
of a forlorn poet smuggling rifles and khat
whose shadow is limping past her future
on his way to nowhere.

Untitled
by Nick Pope

In lapses of golden robes, tranquil beauties lapse time, like syrup drops into the sunset, forever the beginning of the New Dawn.
Fear not the fear, hear not the untruth, let their paranoia be not yours
Class less but not moral less.
Endless spoils of never ending threads turn the jigsaw backwards.
No conclusion begins chapter after verse.
Menu, starters, main dish and desserts......
In the beginning there was the end and it was the cliché!!!

Salvador Dalí
by David Gascoyne

The face of the precipice is black with lovers;
The sun above them is a bag of nails; the spring's
First rivers hide among their hair.
Goliath plunges his hand into the poisoned well
And bows his head and feels my feet walk through his
brain.
The children chasing butterflies turn round and see him
there
With his hand in the well and my body growing from his
head,
And are afraid. They drop their nets and walk into the wall
like smoke.

The smooth plain with its mirrors listens to the cliff
Like a basilisk eating flowers.
And the children, lost in the shadows of the catacombs,
Call to the mirrors for help:
'Strong-bow of salt, cutlass of memory,
Write on my map the name of every river.'

A flock of banners fight their way through the telescoped
forest
And fly away like birds towards the sound of roasting
meat.
Sand falls into the boiling rivers through the telescopes'
mouths
And forms clear drops of acid with petals of whirling
flame.
Heraldic animals wade through the asphyxia of planets,

Butterflies burst from their skins and grow long tongues like plants,
The plants play games with a suit of mail like a cloud.

Mirrors write Goliath's name upon my forehead,
While the children are killed in the smoke of the catacombs
And lovers float down from the cliffs like rain.

Corona
by Paul Celan

Autumn eats its leaf out of my hand: we are friends.
From the nuts we shell time and we teach it to walk:
then time returns to the shell.

In the mirror it's Sunday,
in dream there is room for sleeping,
our mouths speak the truth.

My eye moves down to the sex of my loved one:
we look at each other,
we exchange dark words,
we love each other like poppy and recollection,
we sleep like wine in the conches,
like the sea in the moon's blood ray.

We stand by the window embracing, and people look up
from
the street:
it is time they knew!
It is time the stone made an effort to flower,
time unrest had a beating heart.
It is time it were time.

It is time.

Abstract
by Ted Joans

Dead Serious
I Too, at the Beginning
Bird Lives and Bob Still GIVES
Along the Paris Corso
Why I shall Sell Paris
Afrique Accidentale
Jazz is...

Me, I Was Saying
by Jean-Pierre Duprey

I

The doors close, enclosing one in the others.

A shadow lies gloomily: in its grimace I notice a movement that turns bodies white, which repeats itself behind me, that is what I believe to be me, what should be me...

And in front of what could have been me, light up two eyes gnawing on the same black bone.

It's a ghost in search of the same wisdom. And my shadow was also there.

And I will never know where I was trailing it, since the only thing that happens to be left of that shadow is some black on the inside.

I kept talking, talking...

And there was my ghost. That's all I was. I would wander like that with my clay head and transparent feet. Sometimes looking a little older and other times resembling nobody, and there were times when I was pretending to be a writing ghost, as if ghosts could do such thing as cover the earth with writing. And whenever I yelled, "Break!" a howl would come in response from all the things around. But time would prevail, imposing upon me a shadow, whose yawning abdomen kept endlessly expanding, and the night faked night vision, pretending capable of seeing in there.

Later, so much later, the seas seemed to wave to me, and mothers of hereafter measured me with fish.

II

To the forest, I explain the situation.

After the ruins — of everything that could be essential — I went toward the bed in the bedroom, the bedroom of the bed, what was supposed to be the room, but was only the bed, and not even bed, because beds in the bedrooms are sad, so sad... So much so that birds that we find wrapped in the sheets that have been dead for a while, or not even dead, but cold, and not even cold, but looking dead and shared with their..., by their..., they're... there.

To the forest, I explain the situation.

Between the two heavy eyes — that is very far away — it's all very far, very far indeed — the snow thickens under the knell of heavy moons, the thick snow spells the end, spells it out with the red power of cracked lips and black teeth.

Barely was I anchored at sea — the ship-wrecked situation, when the sea would swell with the last sip of poison.

I mystify, I mystify myself...

Explaining the situation to the forest, to the dugout trees, to the stuffed birds, howling, wearing wolf skin, that skin whose teeth have come to me in a dream...

Untitled
by Allan Graubard

I dreamed that I lost my notebook
I walked through several cities
With a blindfold woven from crow feathers and the sticky
dust
That flakes from sheep hooves
I sleepwalked through the crowds and spun around
corners
As if I were a top thrown by an angry child
Whose mother left her skin drying on the clothesline
In time I lost sense of who I was and where the notebook
might be
This bound vellum casement from which I leaped toward
myself
Inhabited by a shadow and that shadow by a thousand
other shadows
Each searching for their notebook in foreign cities
That curve along rivers or meander out onto upswelling
plains
Where mountains rise and eagles nest
I dreamed that I awoke on an empty street near a tree of
light
That spoke every language ever known
Overwhelming music, beautiful and plenipotent
It rose to a crescendo, my ears throbbing
With the rhythms of time and history
Until it diminished to a low, slow whisper
Which was the sound of your breathing next to me
When I knew that I was no longer dreaming
And the tree of light
And the orchestra of words

And the shadow and their shadows' shadow shadow
Were images
From a dream

I opened my eyes
And this poem
With one voice
Inhabiting one man
At 11:07
On a Monday morning
Was born

The Windowpane
by René Char

Pure rains, awaited women,
The face you wipe off
- Of glass devoted to anguish –
Is the face of a rebel;
The other, the happy man's window,
Shivers before the log fire.

I love you twin mysteries,
I feel you both;
I have pain and I'm buoyant.

Witness
by Philip Lamantia

Because the dark suit is worn it is worn warm
 with a black tie
and a kiss at the head of the stairs

When you hear the dark suit rip
on the heart's curb the hurt is big
 rose flesh caught on the orange woman's buttons

As you talk metropole monotone
 antique intelligence
as you dress wounds by peyote looming the boulevards
women hunt their children from you
who look out
 lit *still* inside of a dark suit

There Are Intersections...
by Joyce Mansour

There are intersections where the night
The joy jumps on the back
Of the passer-by
Such the lonely dawn in the acid wind
The decapitated dies standing up
Below
Body to body in the mud
Teeming furnace
The worms
Whips with triple straps
Caress the tip of the roots
Of flesh
Meat of sacrifice
Gem of the putrefaction
With no burden other than its arms
Tied elbow to elbow
Behind
Bundles of blood on the promised land
Prospectus of fertilizer
There are spittings in the very depths of the mirror
Scratches in the snow
Perjuries languish
In the eyes of our companions
Steam and sweats of the authoritarian woman
Naked on the floor
Vibrating from hatred
"Move along" screams Evangeline
Too late
The well is dry the flies gone
In the jumble of greenery

A slight scent of underarm hesitates
Still
Petticoats from the bark of the phallus
Serve as extinguisher
Setting sun
There are living corpses in the mouth of infants
Weeping willows
Embryos coated with lying wax
In the aqueduct which flows
Over the plain
Tomorrow which will drink our fathers' blood

My Valley
by John Welson

Brooded hills
covet history.

Trodden fields
mist crept.

Metal plough
silenced path.

Sheep crossed
flock creased.

Crow foot valley
streams amble.

My valley.

Wind kissed trees
blink at blood.

Stone wall fingers
gripped earth.

Buzzard warned
torn stomach.

Rain parched
soil breath.

Silenced air

gate open.

There is a scent in this valley
but only I can birth it.
It was given to me,
gifted,
there is a scent in this valley,
rain parched, wind kissed,
sheep crossed,
on my eyelids
my valley looks into me.
I do not raise my eyes,
sun up, again.

('it Doesn't Look Like A Finger...')
by Hugh Sykes Davies

It doesn't look like a finger it looks like a feather of broken
glass
It doesn't look like something to eat it looks like something
eaten
It doesn't look like an empty chair it looks like an old woman
searching in a heap of stones
It doesn't look like a heap of stones it looks like an estuary
where
the drifting filth is swept to and fro on the tide
It doesn't look like a finger it looks like a feather with broken
teeth
The spaces between the stones are made of stone
It doesn't look like a revolver it looks like a convolvulus
It doesn't look like a living convolvulus it looks like a dead
one
KEEP YOUR FILTHY HANDS OFF MY FRIENDS USE THEM ON
YOUR BITCHES OR
YOURSELVES BUT KEEP THEM OFF MY FRIENDS
The faces between the stones are made of bone
It doesn't look like an eye it looks like a bowl of rotten fruit
It doesn't look like my mother in the garden it looks like my
father
when he came up from the sea covered in shells and tangle
It doesn't look like a feather it looks like a finger with broken
wings
It doesn't look like the old woman's mouth it looks like a
handful
of broken feathers or a revolver buried in cinders
The faces beneath the stones are made of stone
It doesn't look like a broken cup it looks like a cut lip

It doesn't look like yours it looks like mine
BUT IT IS YOURS NOW
SOON IT WILL LOOK LIKE YOURS
AND ANYTHING YOU SEE WILL BE USED AGAINST YOU

Untitled
by Desmond Morris

Twilight Song (for Hugo Ball)
by Emmy Hennings

Octaves reel, and through the grey years -- echoes
as heaps of days collapse upon themselves.
I want only to be yours.
Within my tomb my blond hair grows;
in elderberry bushes live strange folk.
A pale curtain whispers "homicide."
Two eyes range restless through the room,
inside our cupboards spirits hide.
Little fir trees are the children's souls
and ancient oaks the souls of aged men
that whisper of miscarried lives.
The cliff-king sings an old, old tune.
I had no guard against the evil eye,
Though black men creep out of the water pail,
The picture book's Red Riding Hood
Has me in thrall for once and for all time.

To Timbuktu
by Rowena Morfydd (Lyn) Bonnin

full of a
balloon fire
a balloon full of a balloon
full
of a balloon full

a balloon fire minion has
been bobbing to Timbuktu
so
orange he was on
fire
this night
has
no words now

my minion has been bobbing
up words and
drinking
my minion has been this bobbing star
for four years
then nothing

to Timbuktu
so orange it was on fire
the fallen from the leaves
have fallen from the leaves
have fallen

my head is full of words
the shape
of a balloon

fire my head
it might explode

Chequered Woman by Jean Bonnin

You Are My One and Only
by John Richardson

You are my one and only
I carry each one of your kisses with me
Your ivory mouth against mine
And crystal tongue
With the passion of raging snow
Falling from a transparent sky
And the taste of wild icicles on my eyelids
Cover me with your luminous cloak
Of Mad Love and desire
Every minute of every day

Untitled
by Ithell Colquhoun

He: If my love could be written down
She: Then the waterfalls would all turn black. If one turned
around three times
He: Then I would fuck you all day long. If my tongue could
reach your womb through your mouth
She: Then the toads would spit fire and all the gates would
creak. If I went on a long sea-trip
He: Then even apple-trees would be monogamous.

Whilst She Kidnaps the Nightingales
by Darren Thomas

Your face in the lion of cloud
Where the leaves shine across her shoulders
She needs to shape the diamonds
When her hands are wet
She needs to take the train at midnight
When her nakedness
Can smile in the moonlight
And your eyes can bathe in the glove of her lips

Tantamount to murder
This invitation to merge in kisses
This concealed prayer to collide in dreams
Your half-lit expression says it all
The flesh that made flesh shudder
Floods the mirrors
With liquid intent
She breathes in sighs
As only an octopus can
When you shape the fire with embraces

Now the air is meted out in handfuls
Now that bodies lose their leaves
The journey is finally beginning
Your teeth are sure of it
It's in the way she responds to fingers
She has the trail of petals
Binding your tongue to hers
She sleeps between your gaze and the one in the room
You trace the outline of larks
Whilst she kidnaps the nightingales

Thirst At First Hand
by John Welson

Waste high in kisses
The boisterous wing of pain
Needles through the rivers of bread
The tobacco of opening water
The breathing leather of mountains
Gloves to penetrate the sickness of fingers soaked in ivy.

Waste high in kisses
Pain
Boisterous as the wing fractures
Bread penetrates the mountain
torn from the fingers of leather.
The singular gap between...
... as arms puzzle their way
through a deluge of kisses.

"… profuse strains of unpremeditated art…"
by Patrick Lepetit

Badlands' benevolent guardian,
madly in love with his own owl-eyed face,
he loved riding through the last ice age
on tired sabre-toothed tigers,
wandering the streets at night,
bruised but bristling with energy
and percussive punch.
Grating dissonances
permeating the world,
showers of light
or clouds billowing all around,
and mischievous creatures
sneaking in as soon as he would leave
the back door of his mind ajar.

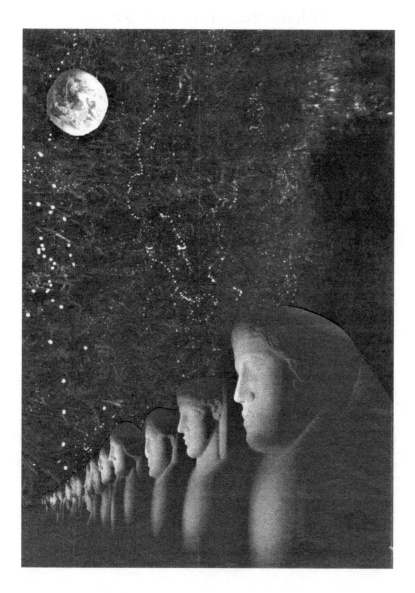

Blank Stare by Patrick Lepetit

A Magical Rendez-vous In Cardigan
by John Welson and Jean Bonnin

Mae Bird sits like chocolate upon cream
Glinting nose stud upon our dream
Conversation is film as rain becomes sandwich
All surrealists roll sideways when drinking from rivers

Words echo with the hurricane of soft winds
Smiled crystal glances pass the grain of oak
Mae Bird your wings are the flight of kisses
Your voice the call of flocked longing

For Cardigan is the dripping of trapped sky islands
The ball bearings of our recollections
Nudged significance through prismed departures
As the rivers of our youth remind us of who we used to be

Morwyn o maenclochog
blue eyed siren
conversation is the river breath
the tide has turned, you will return.

The Spectral Attitudes
by André Breton

I attach no importance to life
I pin not the least of life's butterflies to importance
I do not matter to life
But the branches of salt the white branches
All the shadow bubbles
And the sea-anemones
Come down and breathe within my thoughts
They come from tears that are not mine
From steps I do not take that are steps twice
And of which the sand remembers the flood-tide
The bars are in the cage
And the birds come down from far above to sing before
these bars
A subterranean passage unites all perfumes
A woman pledged herself there one day
This woman became so bright that I could no longer see
her
With these eyes which have seen my own self burning
I was then already as old as I am now
And I watched over myself and my thoughts like a night
watchman in an immense factory Keeping watch alone
The circus always enchants the same tramlines
The plaster figures have lost nothing of their expression
They who bit the smile's fig
I know of a drapery in a forgotten town
If it pleased me to appear to you wrapped in this drapery
You would think that your end was approaching
Like mine
At last the fountains would understand that you must not
say Fountain

The wolves are clothed in mirrors of snow
I have a boat detached from all climates
I am dragged along by an ice-pack with teeth of flame
I cut and cleave the wood of this tree that will always be
green
A musician is caught up in the strings of his instrument
The skull and crossbones of the time of any childhood
story
Goes on board a ship that is as yet its own ghost only
Perhaps there is a hilt to this sword
But already there is a duel in this hilt
During the duel the combatants are unarmed
Death is the least offence
The future never comes

The curtains that have never been raised
Float to the windows of houses that are to be built
The beds made of lilies
Slide beneath the lamps of dew
There will come an evening
The nuggets of light become still underneath the blue
moss
The hands that tie and untie the knots of love and of air
Keep all their transparency for those who have eyes to see
They see the palms of hands
The crowns in eyes
But the brazier of crown and palms
Can scarcely be lit in the deepest part of the forest
There where the stags bend their heads to examine the
years
Nothing more than a feeble beating is heard
From which sound a thousand louder or softer sounds
proceed
And the beating goes on and on

There are dresses that vibrate
And their vibration is in unison with the beating
When I wish to see the faces of those that wear them
A great fog rises from the ground
At the bottom of the steeples behind the most elegant
reservoirs of life and of wealth
In the gorges which hide themselves between two
mountains
On the sea at the hour when the sun cools down
Those who make signs to me are separated by stars
And yet the carriage overturned at full speed
Carries as far as my last hesitation
That awaits me down there in the town where the statues
of bronze
and of stone have changed places with statues of wax
Banyans banyans.

Untitled
by Conroy Maddox

A wax model with stale bread under her eyelids
And the crevice of her armpits sodden with leaves
Chased a tonsured priest in his underwear
Through the corridors of my mind

The Underground Astrolabe
by Joël Gayraud

You can count yourself and your bodies lucky, wild oats!
Bring expectations together around you, like the bright
morning of your corolla skirts, in the shadow of hoodoos
and unfaithful chimney shafts. High on the starry canopy
your tawniest nostalgias can already be seen.

Can You See?
by Jacques Brunius

Sweet nothing is sweeter
Nothing is sweeter to contemplate than a collapsing
church
Can you see the lettuce in the wrecked department stores
The grass is growing in the donkey in the donkey between
its frontal lobes
During the night banks fill with dust
Dust of butter dust of flour
Ashes of black horses buried
Under the debris of electrical filing cabinets

A church is only beautiful when in ruins

The woman dressed in her vest of seeds
Barefooted walking on feet of accountants
Ankle bones
As on candled eggs
Appears sometimes on building sites
To throw the Indian corn of fountains
To harvest the dead wardrobes
To skim the milk of fires
To look beneath the kernel brambles
For the table of her boredom – kernel – where she carved
when young
The name of a very vulgar fish now extinct

Nothing is beautiful nothing is more beautiful
when destroyed than a church

Whistle
by Arthur Cravan

...Leaving all bills behind,
I rolled about like an egg in the crazy greenness of the
grass.
How my shirt intoxicated me! Just to feel its motion,
Not unlike that of a horse, at one with nature!
How I wanted to jig forwards! How I wanted to rush on!
And how good it was on the bridge, tossed about by
music;
And how powerful is the sensation of the cold
When first one breathes!

Flying flags embroidered with my initials
And stamping my commercial power upon the waves.
I also own my first locomotive:
Puffing out steam like snorting horses;
Yet bending its will under expert hands,
It rushes by madly, rigid upon its eight wheels.
It pulls the long convoy on its adventurous trek,
Into green Canada, through virgin forests,
And across my bridges with their caravan or arches,
At daybreak, the familiar fields of wheat;
Or, imagining a town amidst starry night,
It whistles penetratingly through valleys,
Dreaming of the oasis: the station in the heaven of glass,
Amidst the thicket of rails it crosses by thousands,
Where, trailing its long white cloud, it rolls my thunder!

Closing Time
by Emmy Bridgewater

So comes the flame out of the serpent's mouth
So plucks the bloom, the red-tipped fingered hand.
So, as the clock goes round and round and round
So turns again the record of the sound.

Repeat the space where swallows try their turns
Reveal the place where ants begin to crawl,
Remove the time when rain begins to drip,
Re-seal it all.

Poem for Paul Éluard
by Charles Henri Ford

The clouds of dissipation hang like wars
in the peaceful sky of my heart's ease;
the warning birds of wisdom let fall the stars
of their cries in the midst of escaping streets.

The winds of will confabulate,
the clouds grow blacker as if choking;
children gesticulate like toys
at the guns of weather joking.

When my nerves' rain inhabits me,
the salt birds of the brain will melt,
the wind will trickle to the ground,
and underneath the violent tree

the dead cat will be found,
whose eyes looked out from every pore,
and buried like the bone of lust
by children who never mourned before.

Herschel Grynsban
by Herbert Read

This beautiful assassin is your friend:
his action the delivery of love
with magnitude in the unblemished years
when hate and scorn and lust
are buried under the leaves of dread

He lifts his hand in calm despair.
The gesture loses its solitary grace and is caught
thousandfold in the insect eyes of his enemies.
Violence is answered by violence
until the sluggish tinder of the world's indifference
is consumed, consumed to the end

Anger is now action. The white flame of justice
will dance wildly over Europe's dark marshes
until the morning air is everywhere and clear
as on the hills of Hellas

This beautiful assassin is your friend
walking and whispering in the night before you.
His voice is the voice that made you
listen to secrets in the night around you.
The light of worlds beyond your world
beguiled you with hope of a harmony
wider than the anguish of our broken lives.
The wreckage of the day was hidden.

This beautiful assassin is my friend
because my heart is filled with the same fire.

We have sheltered under the same portico
listening to the silver voice of wisdom.
Our feet faltered among the fallen stones
where once the Vandals passed
and we found
under a vivid screen of leaves
the blood still warm from a martyr's wound.

City That Does Not Sleep
by Federico García Lorca

Careful! Be careful! Be careful!
The men who still have marks of the claw and the
thunderstorm,
and that boy who cries because he has never heard of the
invention of the bridge,
or that dead man who possesses now only his head and a
shoe,
we must carry them to the wall where the iguanas and the
snakes are waiting,
where the bear's teeth are waiting,
where the mummified hand of the boy is waiting,
and the hair of the camel stands on end with a violent blue
shudder.

DAHUT
(Bardish song, mixture, first choice)
by Yves Elléouët

Dry skins
Sewing powder with cutout sheets
Needlework
But caves where lizard licks the candle ring
Days nights and come on mechanical bloke
Hahi my hawk
With the wind of red mothers
Strapped and sneering never ever
Little chick cheeky chick playing hopscotch
O old opening of the river
Old estuary of the holy shroud
Your bridge scratch my hair
Jig mistletoe dirty old man
Far from the seal-headed sharks
Prove it prove it that you're a man
Smarsh him in the face and crome on forrward 'arch
And everybody to rise and praise and brand
Female gazelle maid
cursed be the she debauchee
But the shores at the seaside set
O woman your eyes
O woman your breasts
O my very own with a
Ave nearly who then Conan Meriadec
And other with a bladder full of fish
And fishy O and so
And you and Cuchulainn and also other Artus
But nothing in your stained copper-colored suit
O mere shithead said the invader

And What about you said the old the ancient Conan
And dead and trodden sand you are
Old yes with pleated trousers
And let's say without changing a word
Grallon and you Gwenn you old fool
On the azure on azure
Coming sea with all its finest attire
Where your unnamed-haired girl
Since pretty O so pretty that for her
Many and other spiral-eyed knights died

O her long mane
Longer than land and deep seas
And so soft yes so soft
That my hand got stuck in it nothing more.

Tonight
by Jean Bonnin

Tonight
Tonight I will drink
I will drink to live
And to die
I will drink
For all the poets
Who grapple
For my hand in the darkness
So they too can live and die once more

Tonight
Tonight I shall smoke
Smoke the way that lovers do
I shall smoke to all the days
And the nights
And the unhurried afternoons
When we were going to live forever

And I shall love
I shall love the way
When it never used to matter
And yet it mattered more
Than all the stars floating
In my jar of whiskey

And then I shall play
That music you so love
And we shall dance
In that flailed madness
Of delirious beauty

That only
Trapped broken-winged
Moments
Of freedom can breathe

Pleats and Poppy by John Richardson

A Poem That Can Serve as an Afterword
by Mário Cesariny de Vasconcelos

streets where the danger is obvious
green arms of occult practices
corpses floating on the water
sunflowers
and a body
a body for blocking the day's lamps
a body for falling through a landscape of birds
for going out early in the morning and coming back very
late
surrounded by dwarfs and lilac fields
a body for covering your absence
like a bedspread
a place setting
a perfume

this or its contrary, but somehow gaping
and with many people there to see what it is
this or a population of sixty thousand souls devouring
scarlet pillows on their way to the sea
and arriving, at dusk,
next to the submarines

this or a torso dislodged from a verse
and whose death makes everyone proud
o pallid city built
like a fever between two floors!
we'll home deliver
dirt for filling up candelabras
smouldering beds for erect lovers
slates with forbidden words

- a woman for the fellow who's losing interest in life (Here, take her!),
two grandchildren for the old woman at the end of the line (That's all we have!) -
we'll pillage the museum give a diadem to the world and then require it to be put back in the same place,
and for you and for me, favourably situated,
some poison to pour into the giant's eyes

this or a face a solitary face like a boat in search of a gentle breeze for the night
if we're sand that's sifted
in a slack wind among painted bushes
if an intention is bound to reach its shore like the ocean's currents shipwrecks and storms
if the man of hostels and boarding-houses lifts his damp cratered forehead
if the sun outside is shining more than ever
if for a minute
it's worth
waiting
this or happiness in the simple form of a pulse
shimmering amid the foliage of the loftiest lamps
this or the said happiness the airplane of cards
that comes in through the window that goes out by the roof
so does the pyramid exist?
so does the pyramid say things?
is the pyramid each person's secret with the world?

yes my love the pyramid exists
the pyramid says many many things
the pyramid is the art of dancing in silence

and in any case

there are public squares where a lily can be sculpted
subtle regions where blueness flows
gestures belonging to no one boats underneath flowers
a song by which to hear you arrive

NOTES & ACKNOWLEDGEMENTS

Thanks go to everyone who has allowed us to use their pictures and poems; we would also like to thank them for their unwavering friendship, support, generosity, and revolutionary spirit. Your kindness is truly appreciated... We refer to, for example: Lyn Bonnin, Nick Pope, John Welson, John Richardson, and Patrick Lepetit. We would also like to thank A.P. Mousnier for all of the above as well as her help with the cover layout and design of this book – her advice and true artistic eye was much appreciated.

- The D. Tanning poem permitted use with kind permission of Graywolf Press.
- Entry about Ivor Unsk influenced by the article by Eric Wayne from December 2nd 2013, from www.artofericwayne.com.
- William Seaton translator of Emmy Hennings' second poem of this collection is a published poet, critic, and translator.
- 'Surrealism as Diagram' used on page 11 was first used in the book 'Surrealism In Wales' by Jean Bonnin; Black Egg Publishing.

We have sincerely attempted to research all issues concerning copyright and the publication of this work. In the main our investigations and endeavours have been successful. However, should an issue have escaped us we apologise and ask that contact is made with the publisher, who will make all references and amendments necessary. Once again we apologise for any unforeseen issues that may arise.

v. II

Black Egg

Where journey should always be more venerated than arrival Black Egg oscillates between being both *pro-* and *anti-* Black Egg.

In a world where magic, mystery and mythology have substantially been replaced by the crowd-pleasing sugar rush of the short-term gratification of superficiality, here is an Imprint that is not afraid to call itself Surrealist.

For Surrealist and Dada, ideas both old and new - open the door to the strange world of the egg that is black...

Tell your friends (if you have any). Ha ha ha ha ha etc ha ha...

www.redeggpublishing.com

Lightning Source UK Ltd.
Milton Keynes UK
UKHW020911300822
408024UK00009B/1819